Generation Ink

WILLIAMSBURG, BROOKLYN

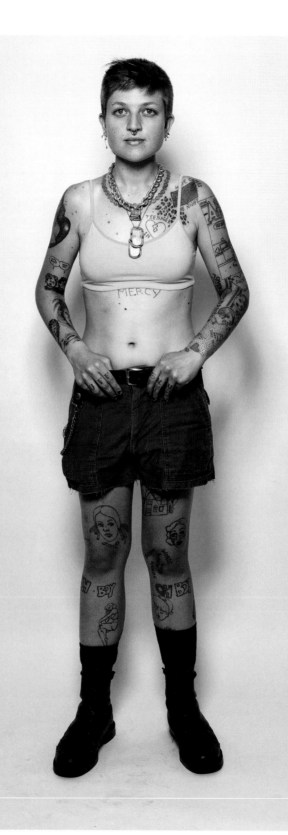

Generation Ink

WILLIAMSBURG, BROOKLYN

Paul Nathan

PELLUCEO

Introduction

Williamsburg, Brooklyn

If you catch the L train from Union Square in Manhattan to Bedford Avenue, the first stop in Brooklyn, you'll begin to notice a marked difference on the skin of your fellow commuters. Straphangers display full sleeves of tattoos, mottos are printed onto chests or forearms, and illustrated worlds unravel on calves beneath cut-off shorts.

Once in Williamsburg, a short stroll up Bedford Avenue and through McCarren Park toward Five Leaves restaurant on the border of Greenpoint reveals a veritable walking art gallery with flesh as medium. "Hipsters"— the men in ironic spectacles sporting mustaches and full beards and wearing flannel shirts and Tom's loafers; the women in vintage sundresses with bandanas knotted above their foreheads—sit on the stoops of brownstones or on the benches outside El Beit coffee shop and Vinnie's Pizzeria smoking cigarettes and showing off their ink. Others whizz by on their fixed gear bicycles flashing heavily detailed designs on their calves and messages on their knuckles. A stop at the boutique In God We Trust is recommended as much for an eyeful of the Sailor Jerry-style flash on the shop assistants' arms as the clothes and vintage sunglasses.

In nearby McCarren Park, young women loll about on the grass in bikinis. Many show off full back pieces, chest pieces, or sleeves—sometimes all three. Their male friends, shirtless in cut-off shorts, have equally elaborate etchings on arms, legs and torsos. And once at Five Leaves, notice the impeccable ink on everyone from the maitre d' to the bar tenders, waiters, and the clientele.

With so much ink on show, it's only natural that the neighborhood would be punctuated with tattoo parlors: Saved, Three Kings, 8 of Swords, Asylum Studios, Flyrite, Twelve 28, Tattoo Culture, and more. Most coveted is the handiwork of celebrity-inker-turned-artist, Scott Campbell who has co-owned Saved Tattoo (with Chris O'Donnell) on Union Avenue since 2004. Campbell, who has a fondness for juvenile, spontaneous tattoos—"all those tattoos that you're supposed to regret when you're older"—has adorned Marc Jacobs with SpongeBob SquarePants and a Simpsons version of himself. He's also accessorized Louis Vuitton menswear models with temporary tattoos and designed a print based on Chinese astrological symbols and LV's logo for scarves, shirts, pants and bags. Other celebs who have gone under his needle include Courtney Love, Robert Downey Jr., Orlando Bloom, and the late Heath Ledger. It goes without saying that the wait to see him is lengthy and will cost upwards of $300.

"Tattoos capture an amazing moment in growing up," Campbell says in an interview on Nowness.com. He describes the process of designing a tattoo for a client as "taking their emotional dilemma and figuring out how to communicate that in a summarized image... In one little concise thing, be it a phrase or a picture." A surprising few tattoo fans have a strong idea of what they would like to commit to their skin or a deep and meaningful reason for choosing what they end up getting. More often they have a loose idea or a couple of visual references and the rest is left up to the artist. It's a concept that might shock those not of the tattoo persuasion. But the members of Generation Ink don't give it a second thought. "I wish people would stop asking me who the girl on my leg is. I don't know!" says Eve Pilar Pappalardo (page 48). "She is someone—I remember Fingers (the artist) telling me she was an actress in the 40's—but I don't remember her name. The piece is a cover up and I gave him full artistic license. You'll have to find him if you want to know."

While we're on the subject, most people featured in this book also hate being asked if they're worried about how they'll look when they're eighty years old (No, obviously) or whether tattoos hurt (Hell, yeah!). Often they get a tattoo on a whim and sometimes simply because a certain parlor is having a sale on flash. "The gun, arrow and heart were all 'specialty tattoos' from shops doing specials on Friday the 13th and Valentine's Day. They were $13 each, plus a mandatory $7 lucky tip," says Lisa Sokol (page 102). It's as if flash has replaced the charm bracelets of yesteryear.

For others multiple tattoos represent a collection of memories. "I think of mine as a scrapbook of stamps that represent who I was or what I was feeling at a certain time in my life," says Frank Palumbo (page 50). Or a form of communication: "I have pretty acute social anxiety, so my tattoos are kind of a way of talking about myself without speaking," says Caitlin Gramm (page 96). Or a way of telling tales: "I like it when people ask me for the stories behind [my tattoos]. That's part of why I get them. I'm a storyteller and it continues on to the ink on my body," says Melissa Lee Connors (page 62). And then there are those who just want to have fun with it all because they can: "I put a pair of sunglasses on the bull tat I have on my left shoulder. I was kind of over the bull so I threw some shades on him and now the tat is rad again. Plus, I thought it would be funny," says Chris Sievers (page 10).

Tattoos, whether adorning the arms and chests of sailors, soldiers, roustabouts, or construction workers, have long moved in and out of vogue. In the United States, they were considered anti-social in the 1960s until rock bands like the Rolling Stones and singers like Janis Joplin got inked. *The Wall Street Journal* reported that by 1972 a new, "modern" tattoo art scene had surfaced across the U.S. as "an expanding group of artists combined fine art disciplines with fantasy motifs executed in the lush, highly detailed tattooing style of the Japanese." The result, wrote Edward Ward, was that "what was formerly considered a sleazy perversion...became just another form of self-expression and style." By the 1990s tattoos were routinely seen on rock stars, professional sports figures, models, and movie stars.

New York City, however, had a slightly different experience to the rest of the country thanks to tattooing being banned in November 1961 after an alleged Hepatitis B outbreak. Tattoo artists went underground or moved to New Jersey to continue their craft. The ban was only overturned in 1997 and a year later the *New York Times* reported, "Tattoos have moved beyond peace signs for hippies and skulls for bikers. A recent fashion in tribal designs—inspired by the work of American Indians and tribes from places like Borneo and Thailand—is now displayed on the ankles and arms of Madison Avenue executives." In 2006, a Pew Research Center survey found that 36 percent of people age 18 to 25, and 40 percent of those aged 26 to 40, have at least one tattoo.

In the past the heavily tattooed were only to be found at circuses, tattoo conventions, in prisons, or motorcycle gangs. Not any more. A mere fifteen years since tattooing was made legal in New York, ink is enjoying unprecedented popularity—and density on the body—especially among Williamsburg's hipsters.

Ever since artists took residency in the North Side's factories in the 1980s, mingling with the existing Polish, Italian, Hassidic and Dominican communities, Williamsburg has been home to many in a creative field. And certainly the majority of the people featured in

this book are aspiring artists. But there are also nurses, chefs, property brokers and pre-school teachers. And it's not just shins and arms that are decorated. Necks and hands, the traditional no-go zones for anyone hoping to hold down a job in corporate America, are also embellished. Heavily tattooing ones body may seem like nihilism to those not of Generation Ink or, at the very least, a rejection of the rat race. But while the evidence on Wall Street may still be thin, slowly but surely visible tattoos are becoming more and more acceptable in regular jobs. Generation Ink are shifting the goal posts.

Photographer Paul Nathan hails from New Zealand. He moved to New York in 2007 and to Williamsburg in February 2010, initially subletting a loft on Grand Street. His inspiration for this book was literally right under his nose: He rang the wrong doorbell and was confronted by his downstairs neighbor, David Hines, shirtless and showing off the top half of an awesome full body tattoo hand drawn to fit the shape of his body by Saved's Chris O'Donnell (see page 83). It took O'Donnell about one hundred hours, over two years, every two weeks with some breaks between sections to complete Hines' tattoo. (According to his web site O'Donnell currently has a six-month waiting list for new clients).

Nathan spent the Spring and Summer of 2011 scouring the neighborhood for equally compelling subjects. He found eager participants whenever he stepped out of his front door: On Bedford Avenue, in McCarren Park, at Smorgasburg, the local gourmet food market, cycling over the Williamsburg bridge, and on the benches outside Café Colette on Berry Street. Some came to his studio alone; others recruited equally adorned friends. All were eager to celebrate their bodies and show off their ink.

Not all of the people that Nathan photographed made it onto the pages of this book. When it came down to editing his close to one hundred portraits he was forced to kill some of his "darlings." The experience, however, left an indelible impression. "When I was in my twenties I felt like I wanted to fit into society and not limit myself too much. What I admire in my subjects is the freedom they have to express themselves and live in the now." And some of those subjects are so intoxicated with this very moment, it inspires their tattoos. See "Just for Kicks" on Chris Sievers' chest (page 10), "Young Hearts Run Free" on Alys Velazquez's waistline (page 74), "Carpe Diem" on Jamie Ryscik's chest (page 86), and "Freedom" on Victoria Carbone's lower stomach (page 12).

Nadine Rubin Nathan

TOM KOGUT, 23, NEW MEDIA ELECTRONIC ARTIST/PIZZA MAKER

How much have you spent on your tattoos? **A bunch.**

Which artists have you worked with? **Most of my tattoos were done by Beau Velasco who passed away in September of 2009. He was a dear friend.**

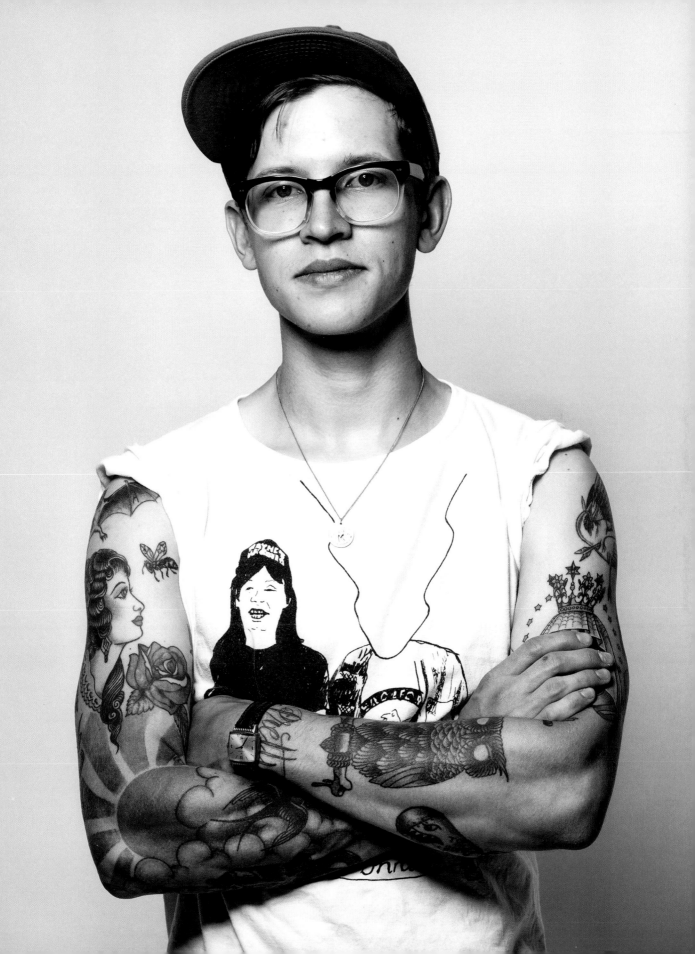

"I put a pair of sunglasses on the bull tat I have on my left shoulder. I was kind of over him so I threw some shades on him and now the tat is rad again. Plus, I thought it would be funny."

CHRIS SIEVERS, 27, FREELANCER/PARTY ANIMAL EXTRAORDINAIRE

How much have you spent on your tattoos? **All my money.**

Did you design your tattoos? **I usually tell whoever is going to tat me what I want and have them draw it up right then and there. So I guess I didn't design them personally but they also didn't already exist.**

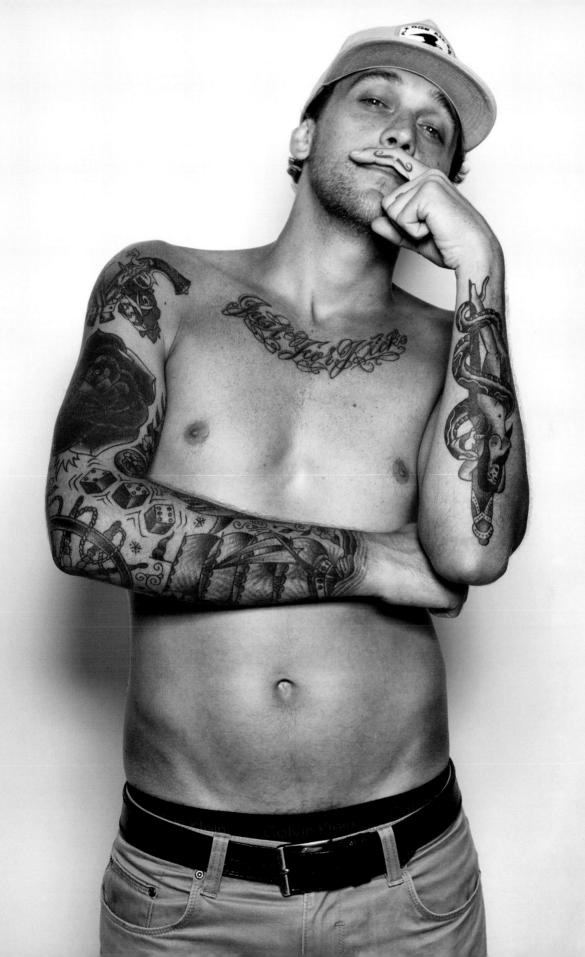

"I wish people would stop asking me how I will cover my tattoos at my wedding!"

VICTORIA CARBONE, 23, GRAD STUDENT/DEEJAY

How much have you spent on your tattoos? **Way too much. But you get what you pay for.**

First tattoo? **I got the Misfits' fiend skull done at a tattoo shop on St Mark's Place when I was fifteen. I had wanted this tattoo for years. Now it's covered up.**

Any other inspirations? **My left arm is all Goya etchings.**

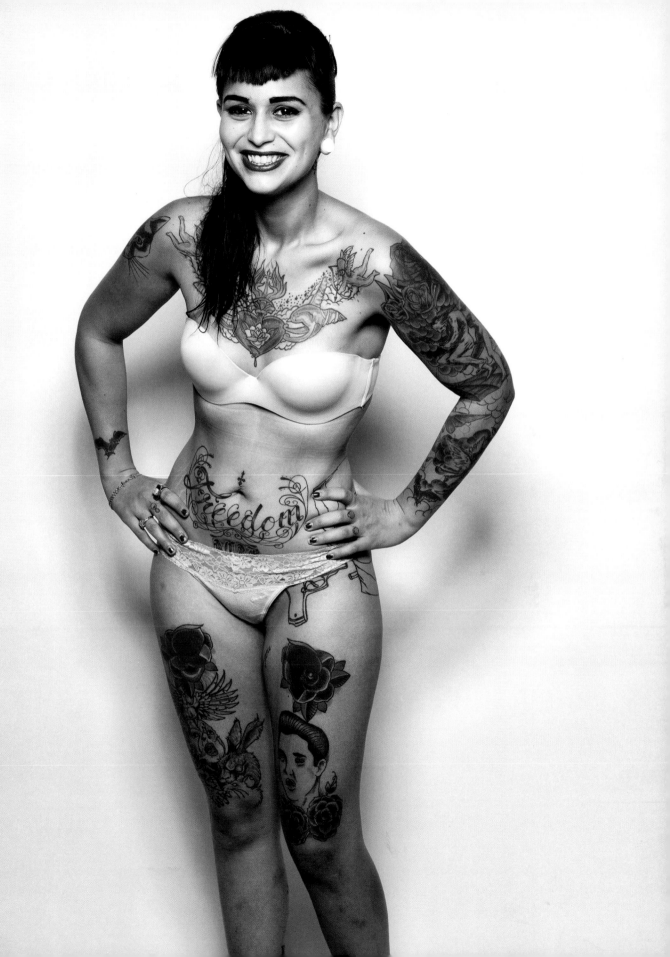

VICTORIA SNICKARS, 22, TOURS WITH BANDS DOING MERCHANDISE

How much have you spent on your tattoos?
A few hundred dollars. I worked at tattoo shops so I got deals.

Favorite tattoo style? **I love traditional Japanese art.**

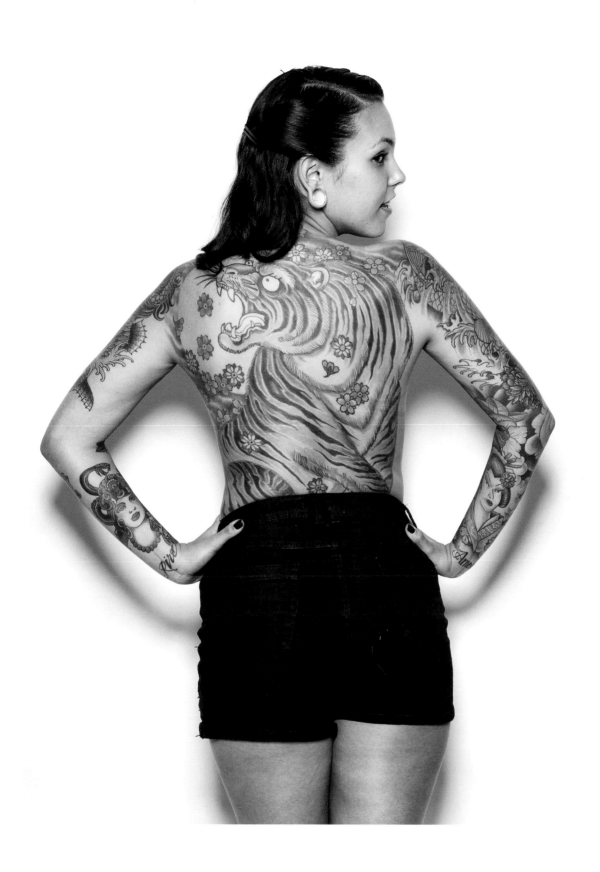

BILLY BRAHN, 24, RETAIL AT FRED PERRY

How much have you spent on your tattoos?
Close to $1,000 I guess. Friends usually hook it up.

Last tattoo? **I just had the Grim Reaper tattooed on my leg. There's no meaning in this one. It's just funny.**

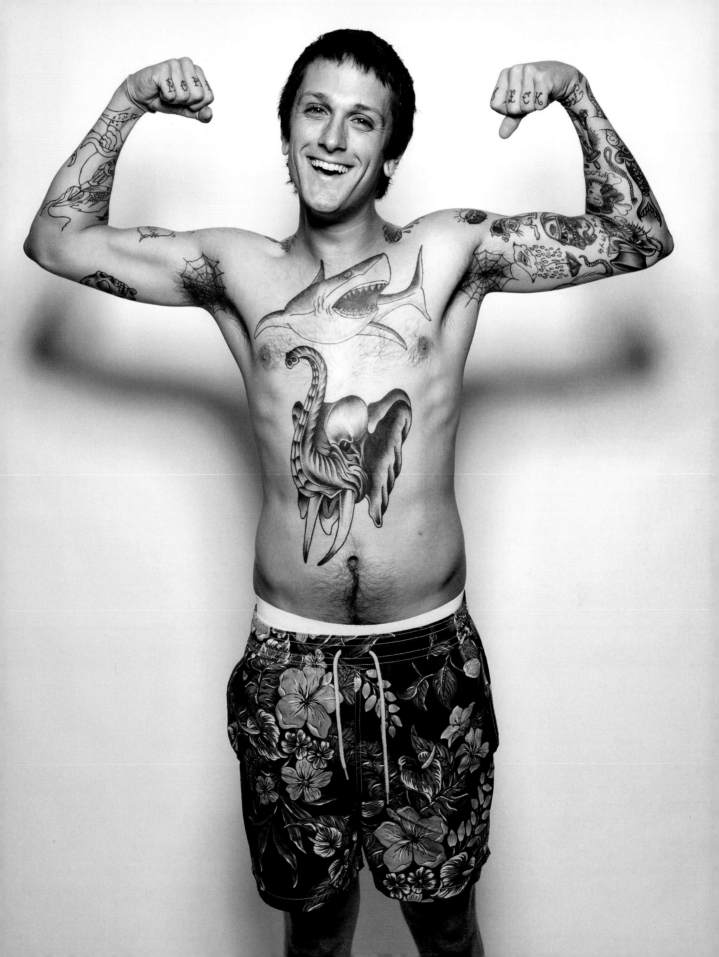

"I want to support any artist who has worked on me, and for some reason most people don't ask who the artist was."

THURMAN WISE, 26, BARTENDER

How much have you spent on your tattoos? **A true gentleman never tells.**

Last tattoo? **It's a work in progress, by Jason June of Three Kings. It's on the back of my calf and it is a woman seated in roses with a dagger behind her back. It was a design by the artist that I stumbled upon and fell in love with.**

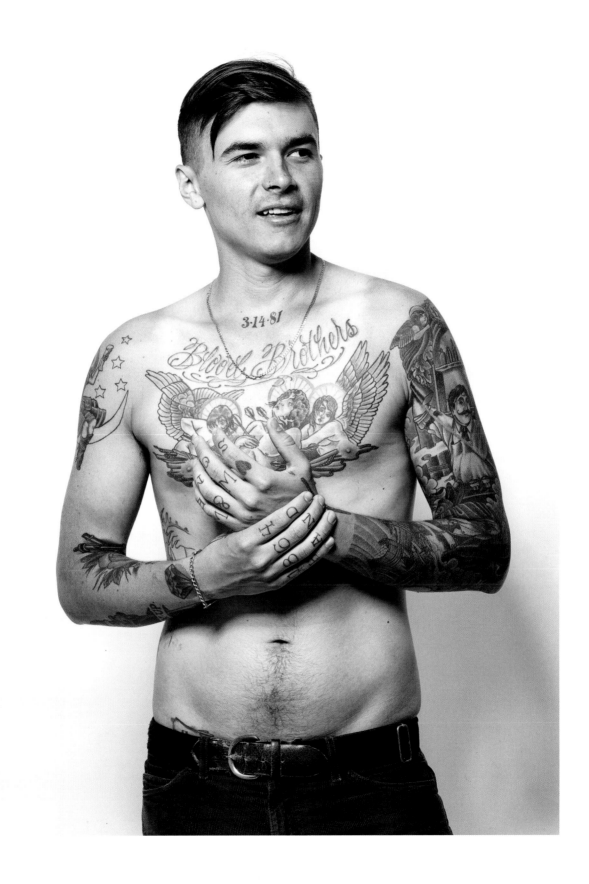

"I had 'No Guts, No Glory' tattooed across my chest after a very rough year. It reminds me that one can't sit back and expect things to happen. I want to do more in my life than be afraid to try."

SHELLY NEIGHOFF, 22, PROFESSIONAL BODY PIERCER

How much have you spent on your tattoos? **I honestly haven't even spent $1,000. Most of my pieces were done by my boyfriend Daniel Clayon Smith, a professional artist, or my co-workers in the shop over the years. I plan to collect from some favorite artists in the future, though.**

Have you ever designed a tattoo?
The Phoenix on my back. I drew it a few years before my eighteenth birthday.

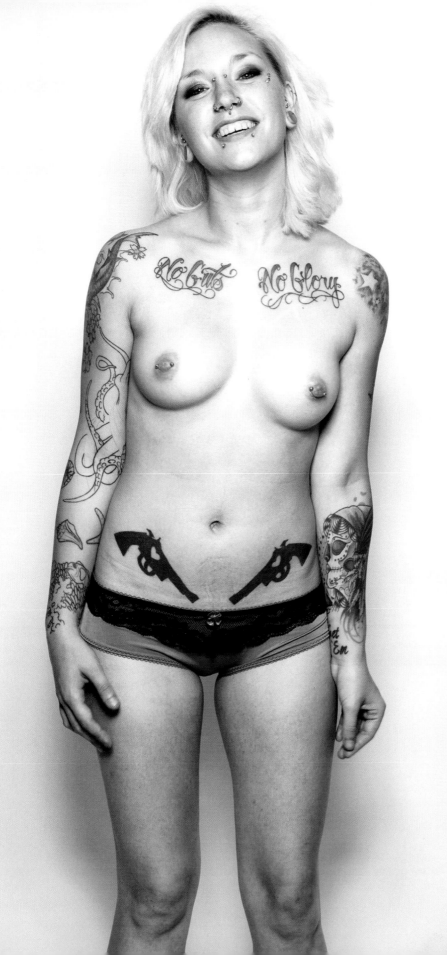

AKIRA LATANZIO, 24, RETAIL

How much have you spent on your tattoos? **No idea.**

First tattoo? **A tattooer in the L.E.S did my chest piece. I have no idea why I chose it. I just remember being super into religious imagery at the time.**

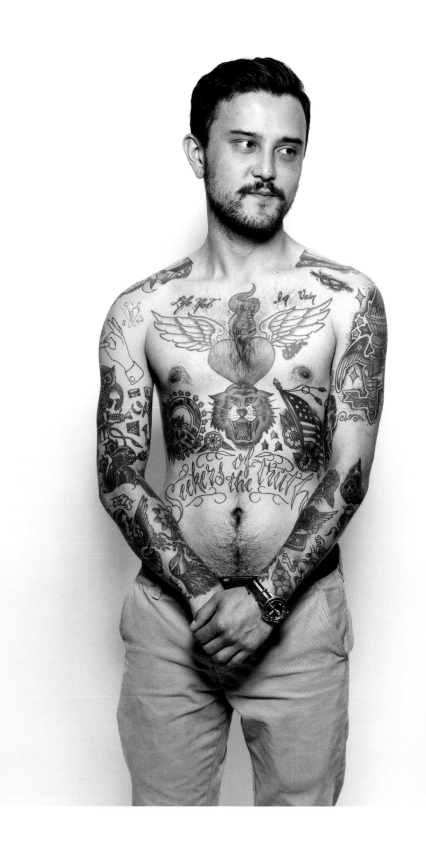

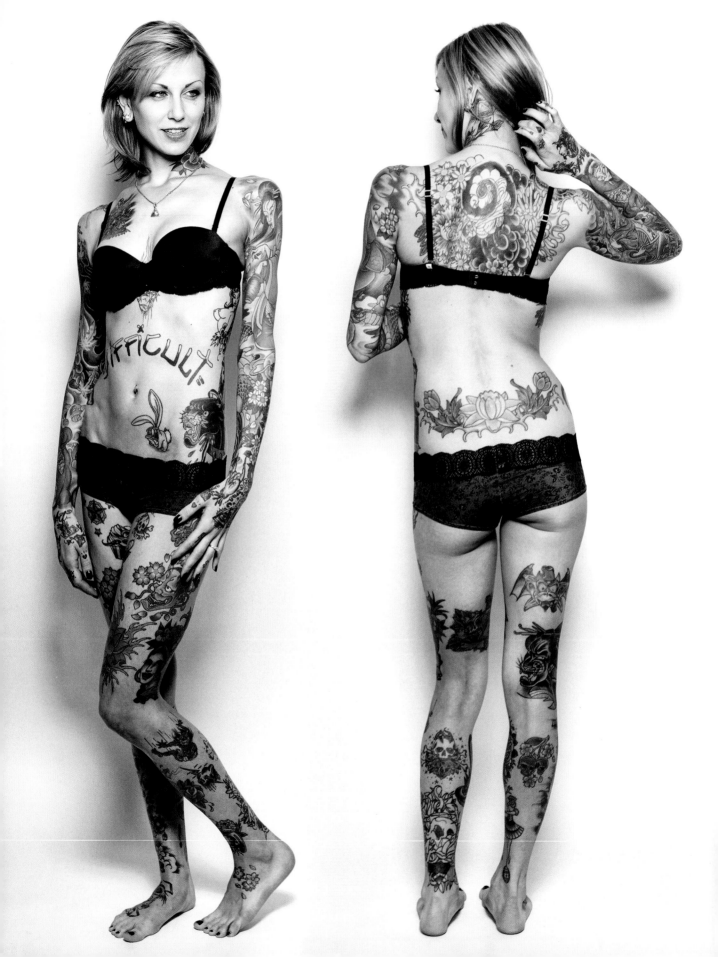

SERENA MAGNETTA, 27, MAKEUP ARTIST

How much have you spent on your tattoos? **Unknown.**

First tattoo? **Nautical stars. They were done by my fiancé, Jamie Ryscik. We met ten years ago. I chose stars because I knew it was a design I'd never regret.**

CLINTON BEAHM, 28, NURSE

How much have you spent on your tattoos? **$9,000+.**

First tattoo? **A red life-star surrounding the staff of Asclepius. I chose it because I was beginning as a nurse and I wanted to have a symbol demonstrating my devotion to the cause. It also reminds me of a super hero's insignia.**

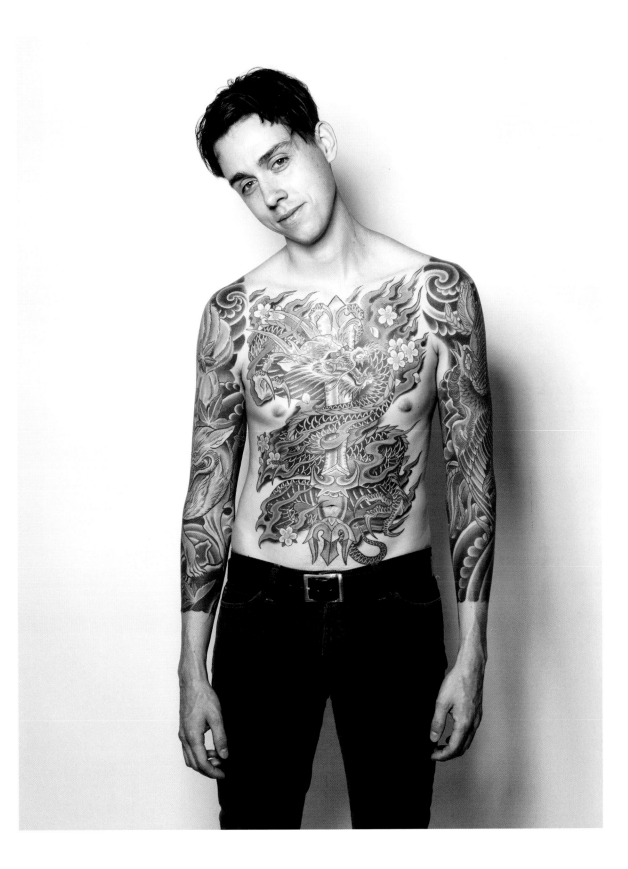

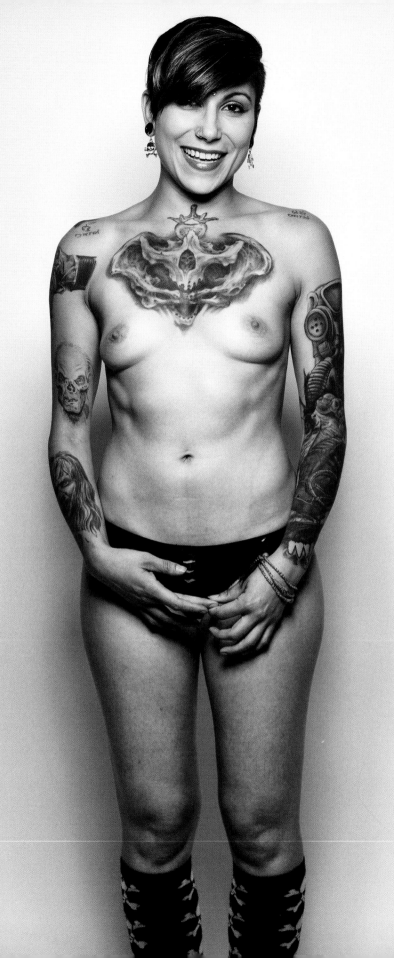

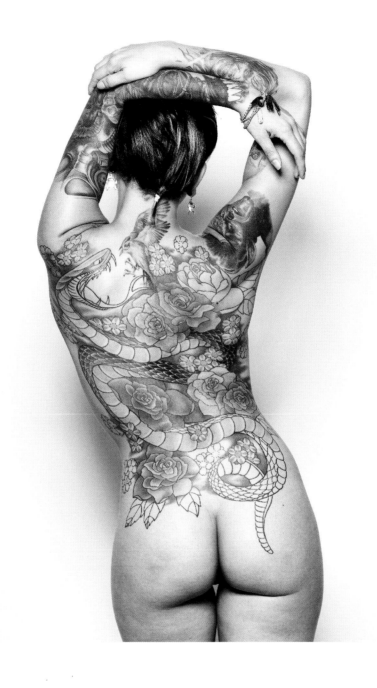

ALICIA LACAVA, 30, SHOP ASSISTANT/AIRBRUSH ARTIST

How much have you spent on your tattoos? **Not enough considering the amazing artists that have blessed me!**

Do you tell the artists what you want? **No, I give them full range artistically unless it's a portrait.**

"I just had a sugar gypsy skull tattooed on my right bicep. It doesn't have a real meaning. I just got it because I felt like it."

ADAM KOBYLARZ (SNAKE CHILD), 25, ACTOR/MUSICIAN

How much have you spent on your tattoos? **Damn....haha. I'd say well over $5,000.**

Why did you get a rose as your first tattoo? **I got it for my mother. Her first tattoo was a rose that she got in the '70s.**

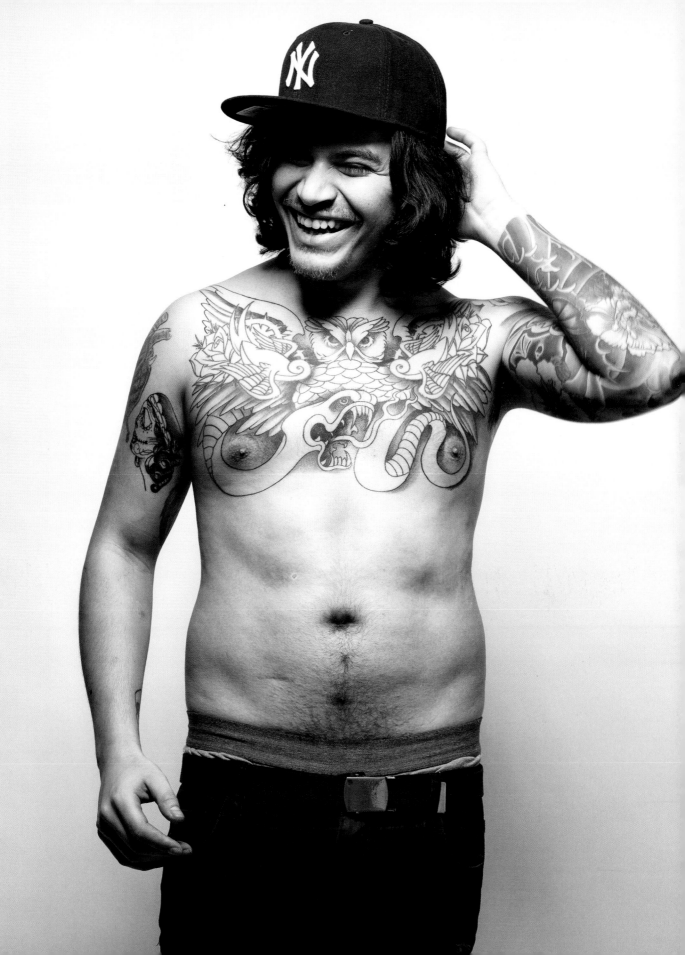

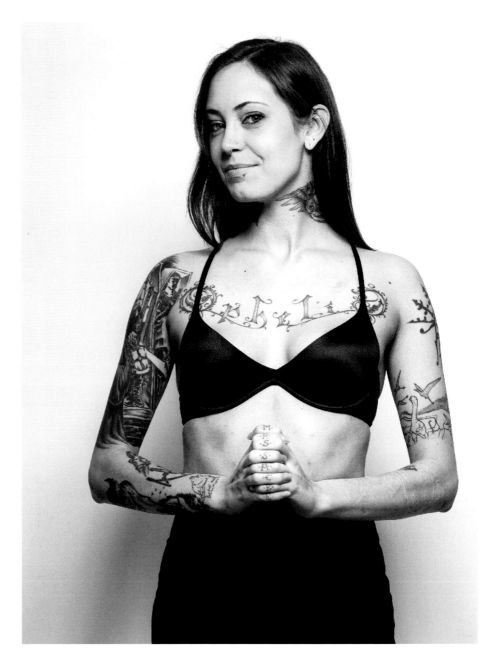

STARR BELEW, 24, BODY PIERCER

How much have you spent on your tattoos? **I've only ever tipped since
I work in [tattoo] shops. How much I really don't recall.**

Did you design any of them yourself? **Most of my tattoos weren't my idea.
The artist did something they felt like doing.**

What's the story behind your most recent tattoo? **One of my very best friends, David Williams, is a tattoo
artist. We have a lot of inside jokes about wolf packs and being lone wolves. He chose a simple wolf's
head outline and we tattooed it on each other. He did mine on my wrist.**

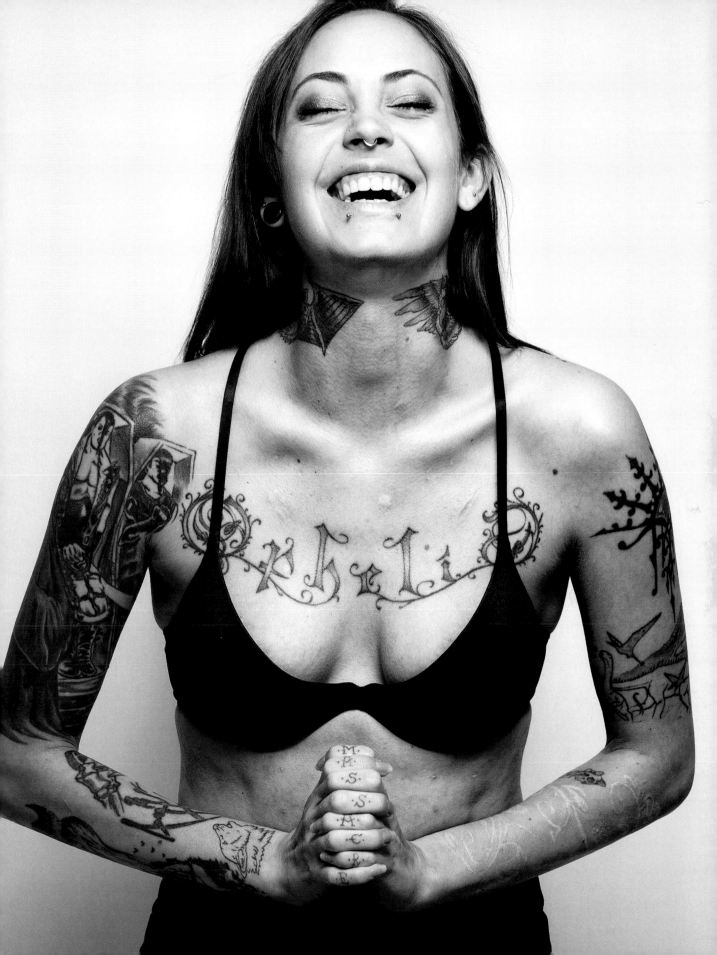

"I wish people would ask me if I am evil."

OLIVER HEARTMONT, 21, MODEL

How much have you spent on your tattoos? **Maybe around $3,000.**

Tell us about your chest piece. **I wanted to cover my old tattoo which was Japanese script. I got inspired by a villain from a video game. It was a dark angel and I just fell in love with it.**

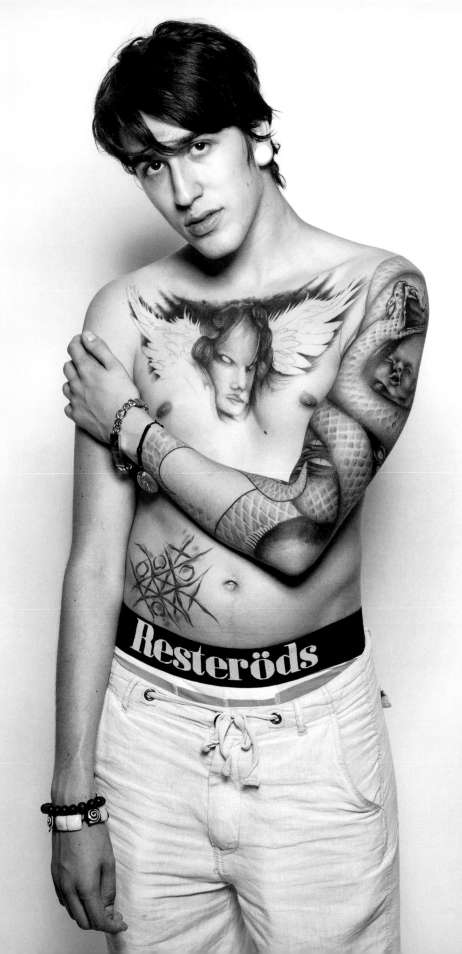

"The draping jewelry on my right hip means constant classiness to me. Jewelry always makes a lady look classy."

WHITNEY E. ALBERT, 25, FREELANCE PHOTOGRAPHER

How much have you spent on your tattoos? **I haven't spent more than $500 for all my tattoos. I dated Andy [Ferko, a tattoo artist] for the time he was tattooing me.**

Did you design any yourself? **No, but I collaborated on the placement, subject and flow of them.**

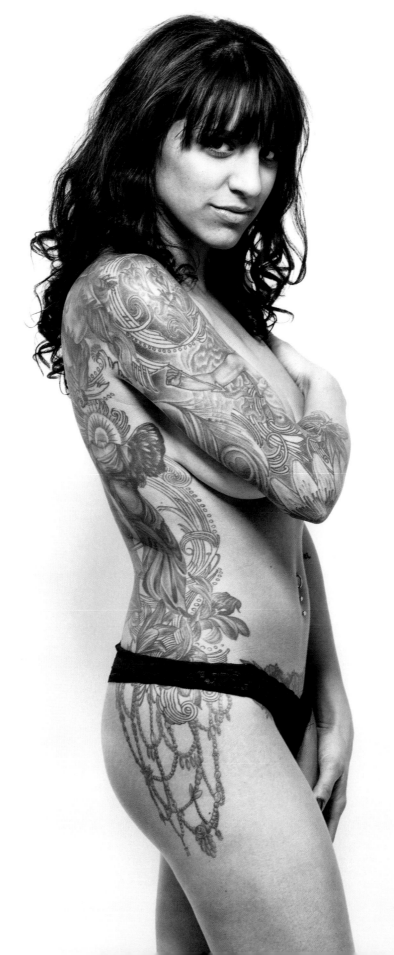

"What am I going to do when I'm eighty? Um…be eighty and cooler than you? I don't know. I don't think that far ahead!"

PRISSY DAUGHERTY, 28, HAIRSTYLIST

How much have you spent on your tattoos? **A couple thousand dollars.**

Last tattoo? **My father's first and middle name. He is an amazing person in my life and I wanted to honor him, just in case I don't tell him enough how much he means to me. I will be getting my mother's name soon too.**

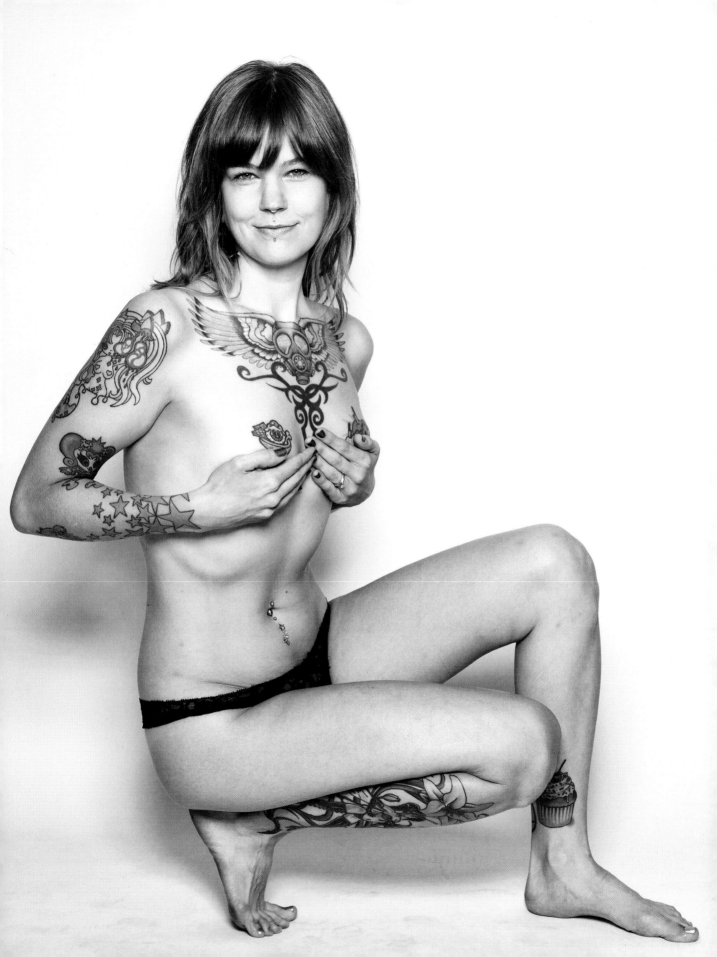

"You get what you pay for in life and that includes tattoos"

BRETT DAVID, 31, STYLIST

How much have you spent on your tattoos? **$10,000.**

Any recent tattoos? **Yes, Regino Gonzalez at Invisible NYC on the Lower East Side did the outline of an octopus on my sleeve. I like the nautical theme and have always been obsessed with octopi.**

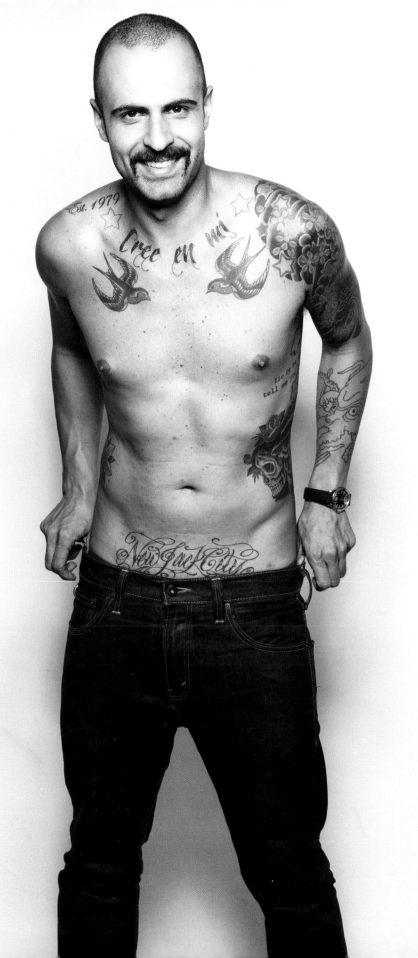

MARISSA TRAN, 24, PASTRY COOK

How much have you spent on your tattoos? **I have no idea.**

What inspired your choices? **I chose a lot of my tattoos
out of flash books (old-school Sailor Jerry).**

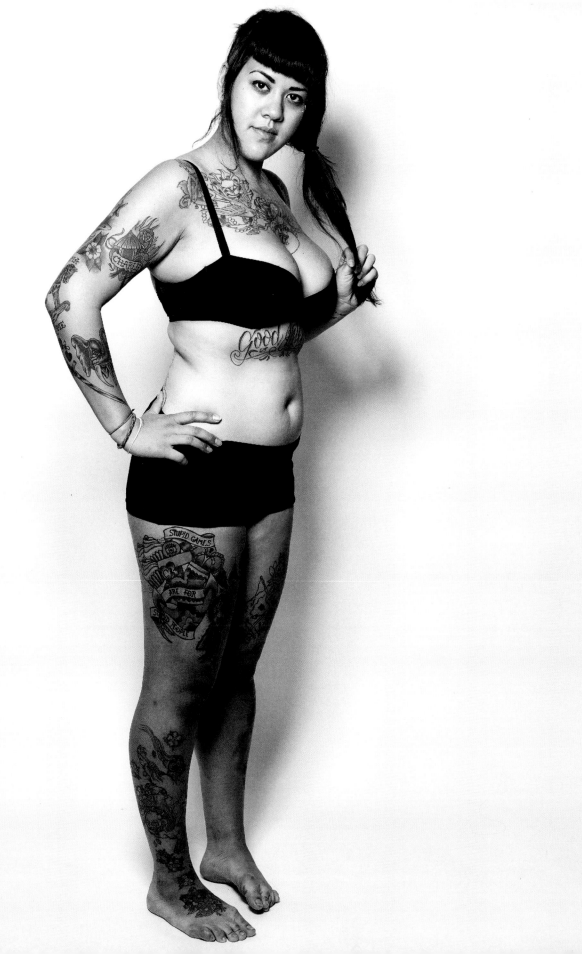

"My rosary-shaped piece has my mother's artwork at the center and base. She taught me to draw when I was really young and I always admired her art."

JAMES KING, 27, WRITER

How much have you spent on your tattoos? **About $2,000. Original pieces cost a lot.**

What is written on your chest? **It's a letter to my family. I wrote it when I was seventeen or so and decided to tattoo it by my heart. My family and I have been through so much together – poverty, homelessness, sickness, you name it. So they are dear to my heart.**

Are all your tattoos originals? **Yes. I put much thought into them before committing them to my body.**

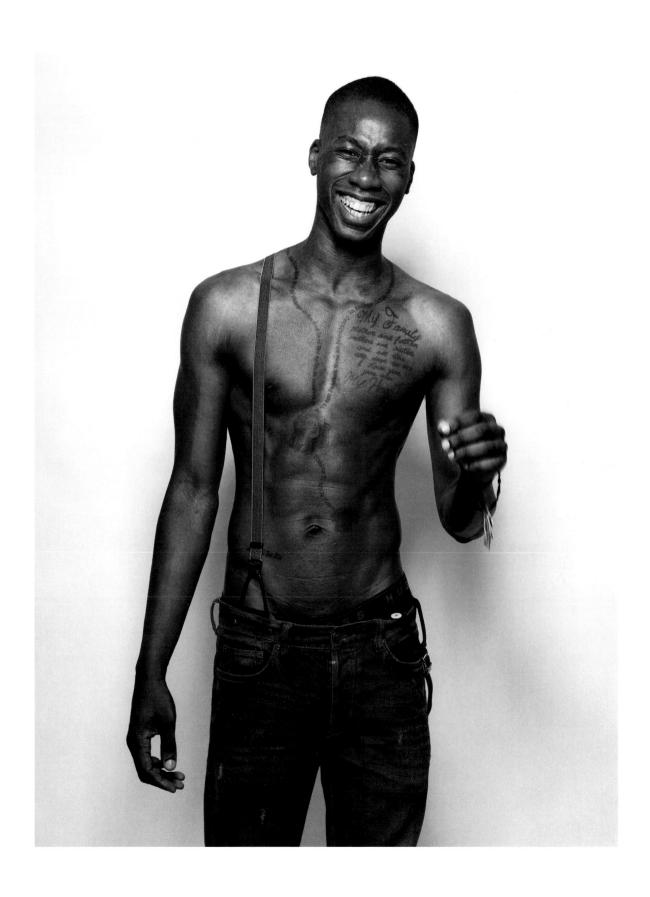

"My side tattoo is a piece by my favorite artist, Aubrey Beardsley, from Oscar Wilde's book, Salome."

CARA, 21, PRESCHOOL TEACHER

How much have you spent on your tattoos? **$600.**

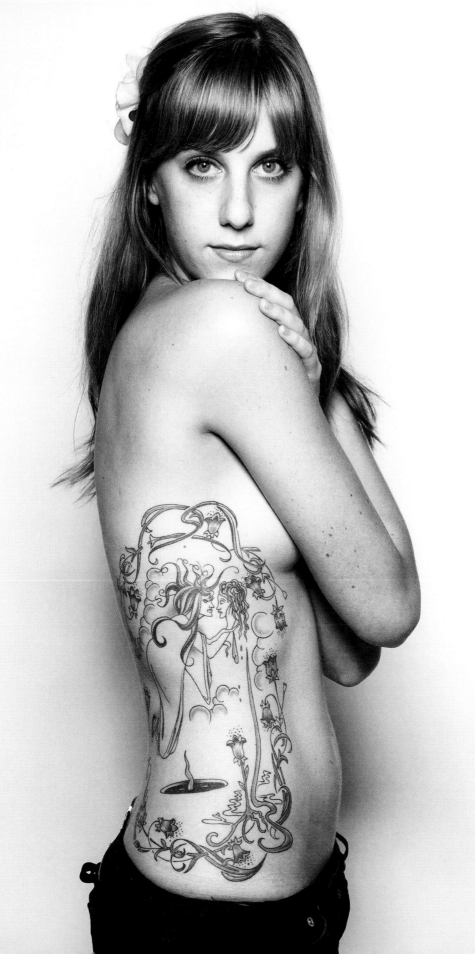

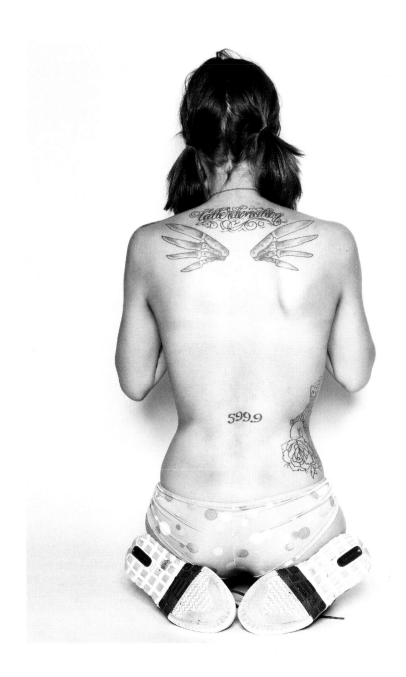

EVE PILAR PAPPALARDO, 21, BABY CHEF

How much have you spent on your tattoos? **Not very much, actually. The majority were done on the barter system—the use of my car for a weekend; the use of my heart for a year and a half. Et cetera.**

Did you design any of them yourself? **I drew the knives that are now on my back while I should have been taking notes in culinary school. The rest were created by the various artists especially for me.**

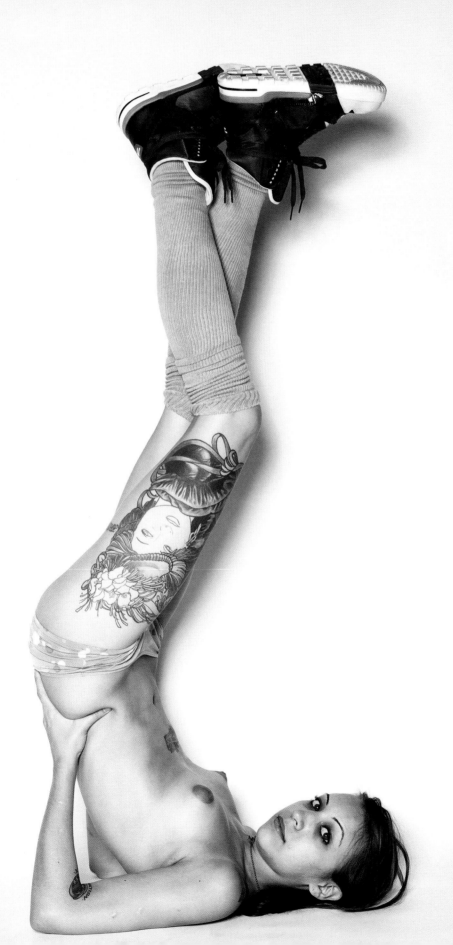

"I think of my tattoos as a scrapbook of stamps that represent who I was or what I was feeling at a certain time in my life."

FRANK PALUMBO, 26, FREELANCE PRODUCER

How much have you spent on your tattoos? **Between $8,000 and $9,000.**

What does FMP stand for? **Those are my initials. I had them done on my stomach in a drippy NYC basement by a guy named Freestyle Alex. I was sixteen years old and I knew that my initials wouldn't change. Plus I could tell girls that it meant 'Fuck Me Please.'**

What about SBF on the inside of your lip? **Shotgun Bulletproof Forever. My best friends and I used to say it when arguing for the front seat of the car.**

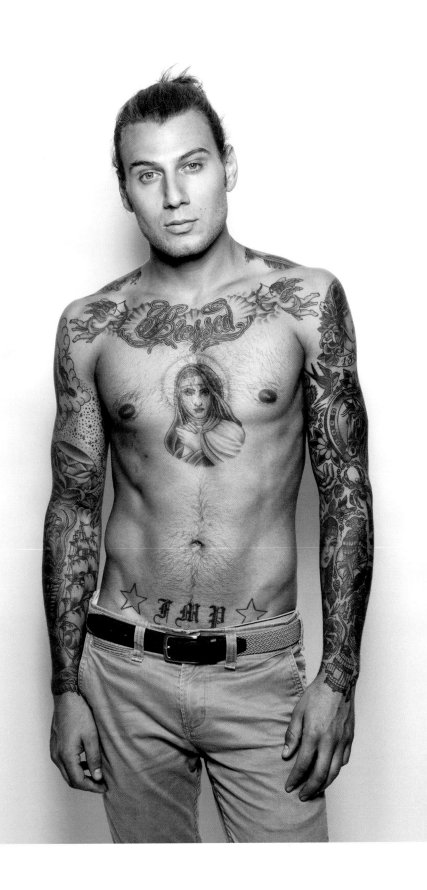

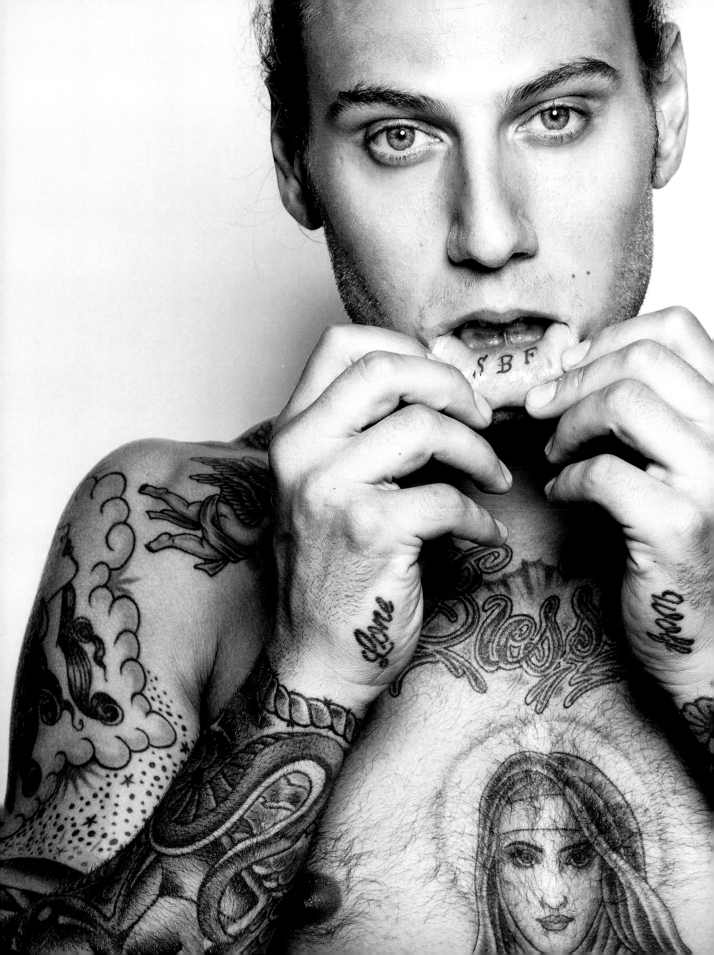

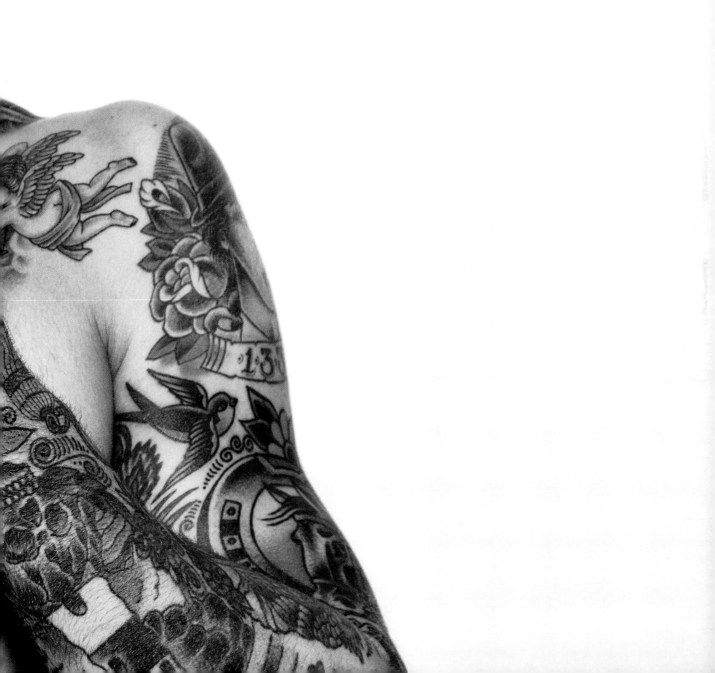

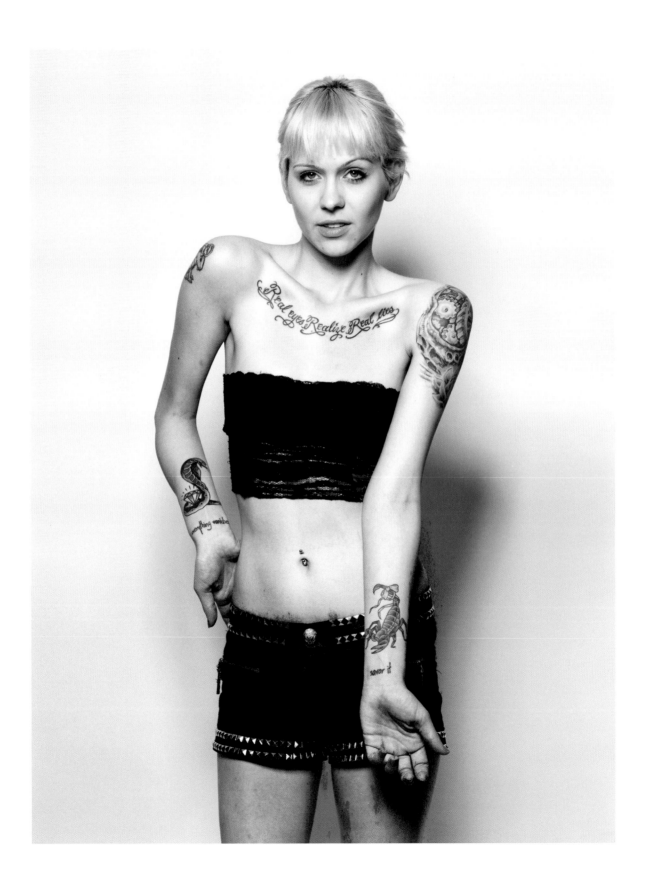

"I got the word 'Hu$tlin' on my inner lip because I don't have a regular nine to five job, so everyday I'm trying to make money. Mostly it's a motivational joke."

AMANDA LENSINK, 21, MODEL/BARTENDER

How much have you spent on your tattoos? **About $1,000.**

Any tips for a newbie? **The best first tattoo spot is your inner lip. Super easy.**

What was the inspiration behind your chest piece? **The 'Realize' quote is from one of my favorite poems called 'Flashy Words' by a spoken word poet named Shihan.**

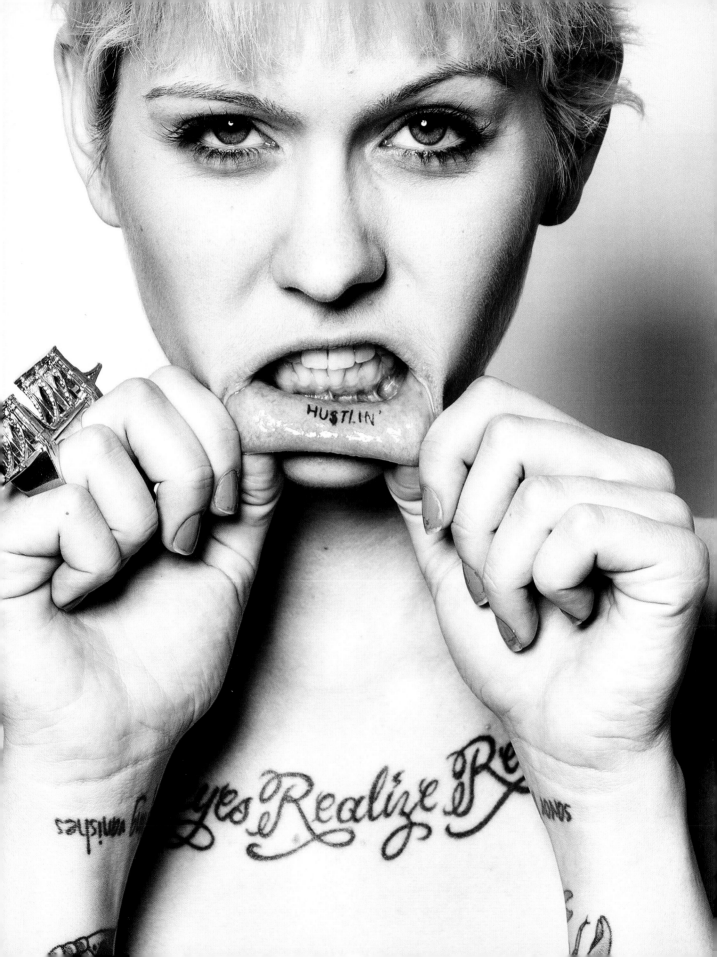

"I chose the tattoo on my rib cage because 'Rose' is my middle name, a name passed down among the women in my family."

SARAH, 21, STUDENT/GRAPHIC DESIGNER

How much have you spent on your tattoos? **Unknown.**

Most recent ink? **Ashley Love at Twelve 28 Tattoo did the birdcage on my hip.**

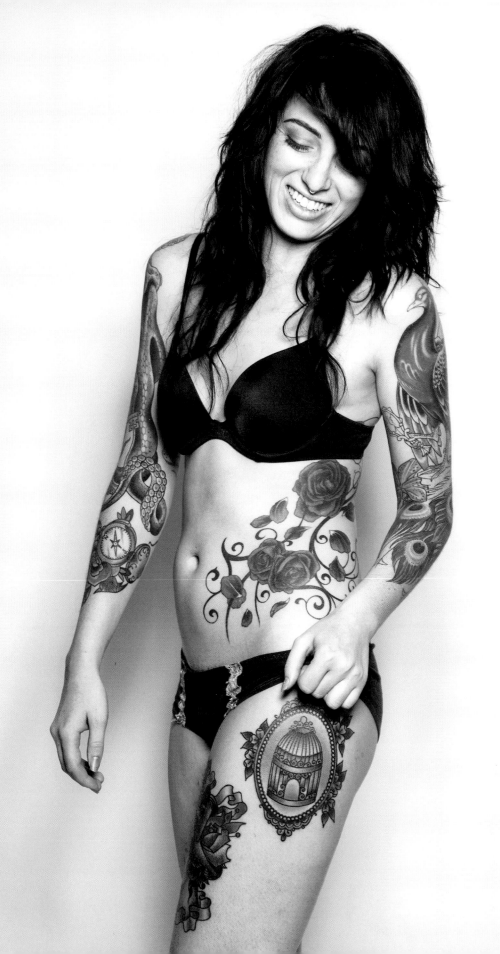

"The 'Heal Hurt' on my double knuckles is another set of 'best friend tattoos' that my friend Antonio and I have together."

LIAN TONGOY (TRON), 29, ELECTRIC TATTOOER AT
THICKER THAN WATER IN THE EAST VILLAGE

How much have you spent on your tattoos? **Money is weird. I have no clue.**

How did you choose your ink? **Most of my tattoos were either designed by friends who are tattooers or they are classic American traditional tattoo designs.**

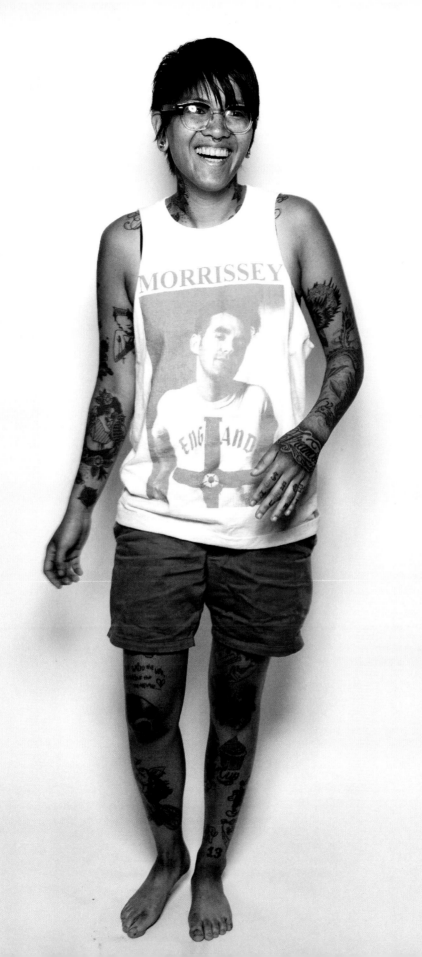

MELISSA LEE CONNORS, 25, BARTENDER/COMEDIENNE

How much have you spent on your tattoos? **Somewhere over \$1,300 for six tattoos.**

What do you wish people would ask you about your tattoos? **For the meaning or stories behind them. That's part of why I get them. I'm a storyteller and it continues on to the ink on my body.**

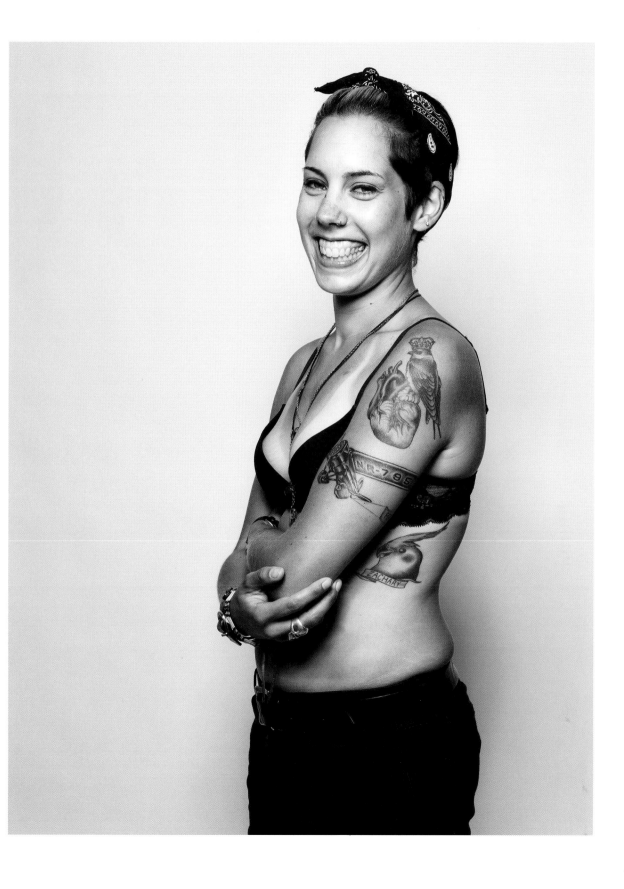

"Stop asking if tattoos hurt. Yes they fucking hurt. It's a needle dragging on and penetrating your skin. It will hurt and you will bleed. Deal with it."

NIK ROGERS, 25, PRODUCTION ENGINEER

How much have you spent on your tattoos? **Very little. I was a [tattoo] shop manager for three years and did trades.**

Did you design any yourself? **I collaborate with artists. Almost everything is original design. My most recent tattoo—the Lion of Judah on my left calf—was designed and tattooed by James Degler at Imagine Tattoos.**

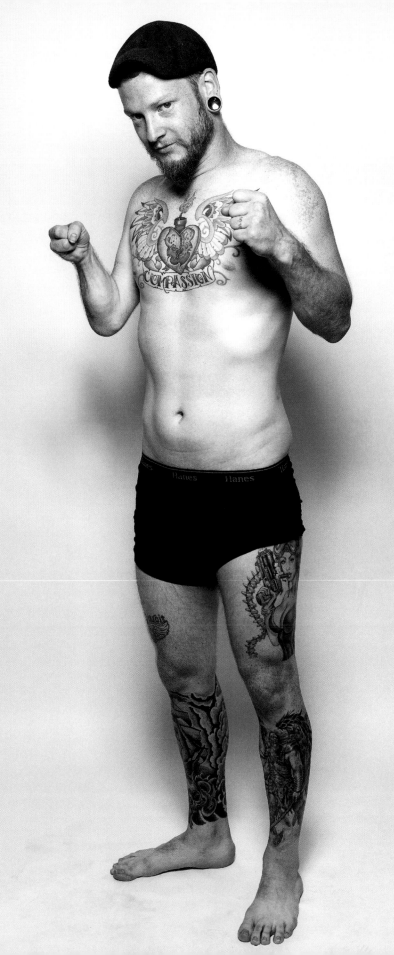

"My Singh or mystical lion is surrounded by Khmer script, I had it done in a temple in Phnom Penh. Afterwards a monk recited scripture over it to make me more powerful in war."

BERYL CHUNG, 23, ILLUSTRATOR

How much have you spent on your tattoos? **$1,000.**

First tattoo? **I got seagulls on the inside of my left wrist in Paris when I was seventeen, sort of to commemorate getting to run around while I was young and stupid. Some friends and I found a tattoo artist from San Francisco, which seemed serendipitous at the time since none of us was confident negotiating in French.**

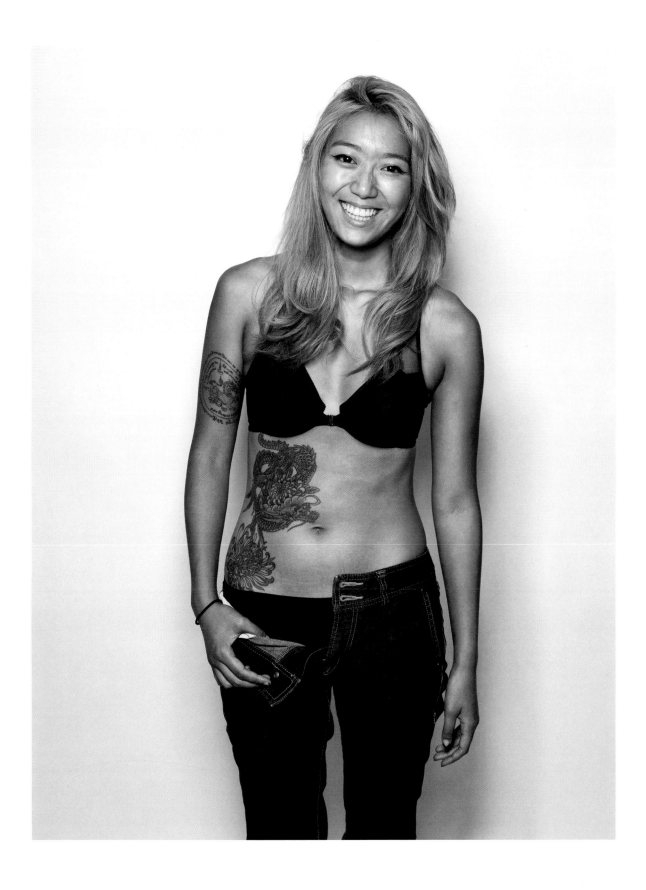

"My favorite piece is the Millennium Falcon on my right forearm. It isn't meaningful. I'm just a huge Star Wars geek and the Falcon excites me every single time I see it."

SHANIQUA WHITFIELD, 21, FULLTIME BALLER/MUSICIAN

How much have you spent on your tattoos? **Ouch. Definitely over $1,000.**

Did you design any of your tattoos?
I only designed the tiny piece on my left wrist and my first tattoo, the very new school Japanese wave on my right bicep. It features tiny symbols that remind me of each of my immediate family members.

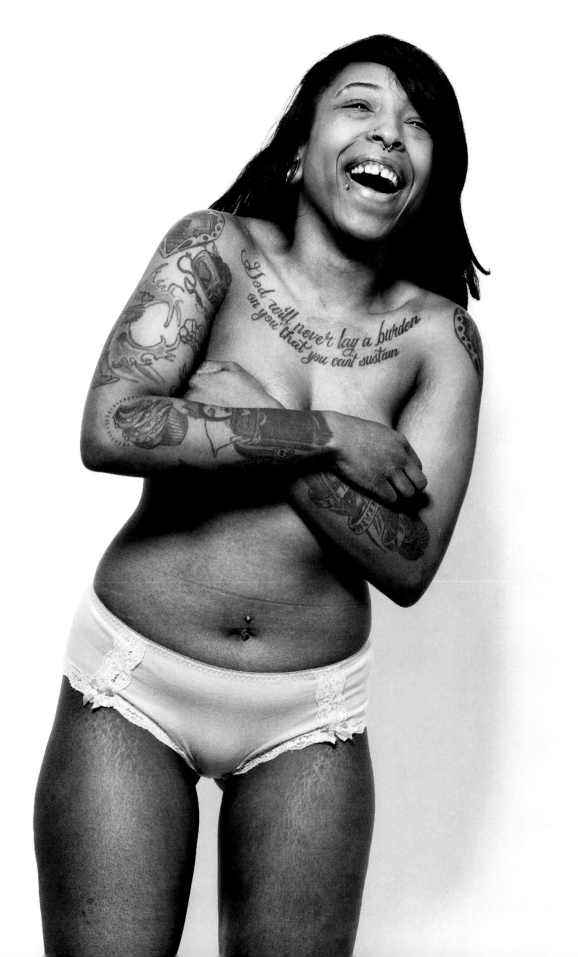

JUSTIN GOSLIN, HAIRSTYLIST AND MAKEUP ARTIST

How much have you spent on your tattoos? **They were all done on trade.**

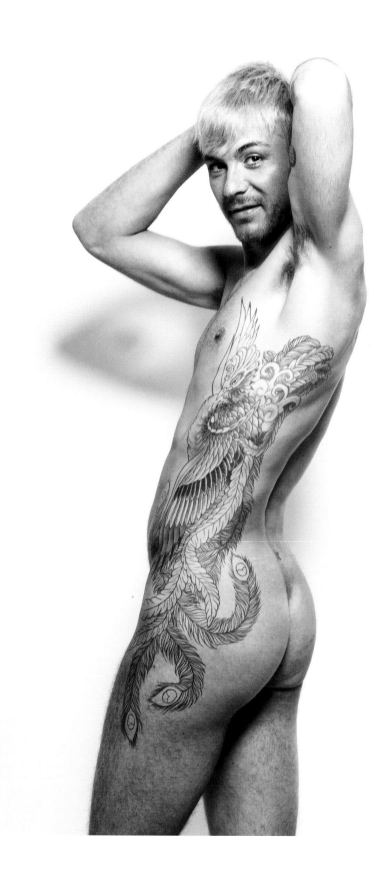

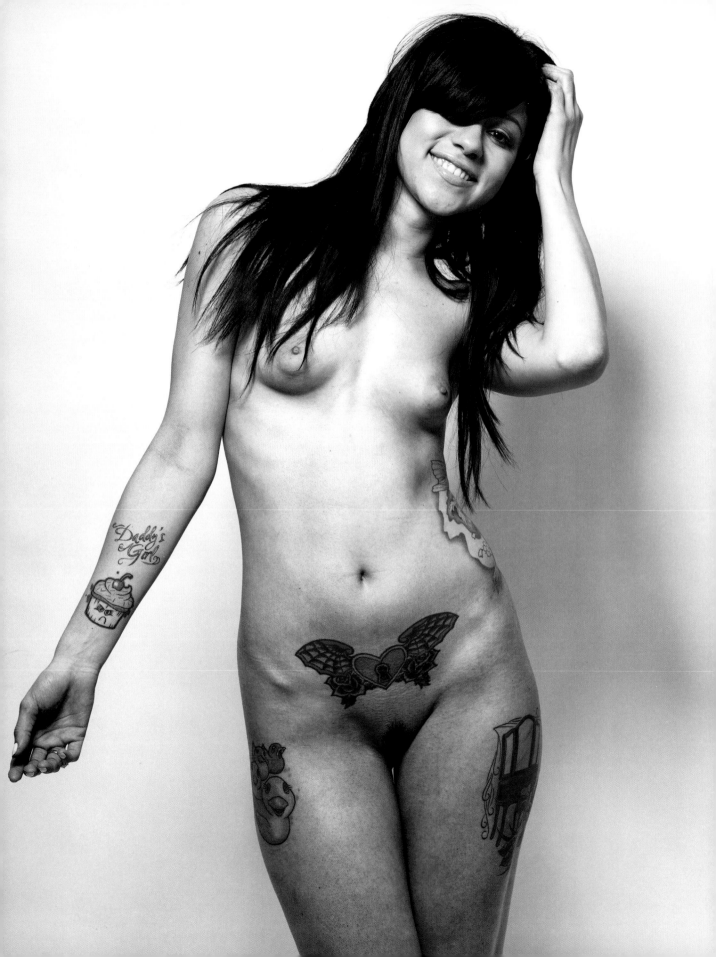

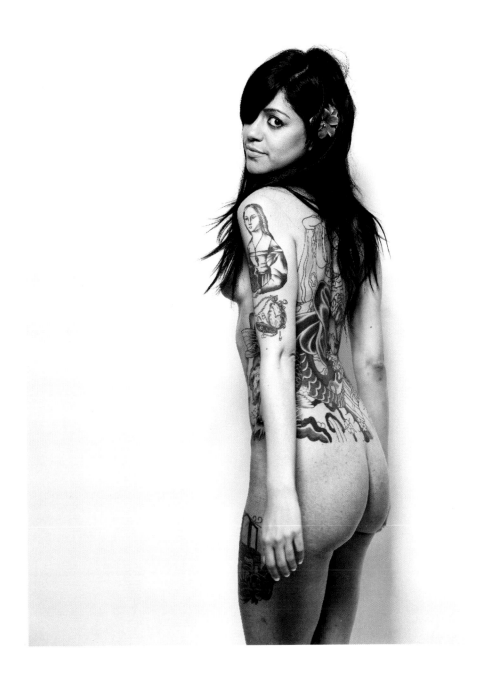

JOHANNIE VALDES, 23, ALTERNATIVE MODEL/MAKEUP ARTIST

How much have you spent on your tattoos?
Over $1,200 and I am currently still spending to complete my back piece.

ALYS VELAZQUES, 23, BARTENDER

How much have you spent on your tattoos? **About $800 or so. I'm a generous tipper.**

What was your last tattoo? **A leopard print heart and pink bow with lace trim. It was done by Ashley Love at Twelve 28 Tattoo Studio. It's my 'Wild at Heart' tattoo.**

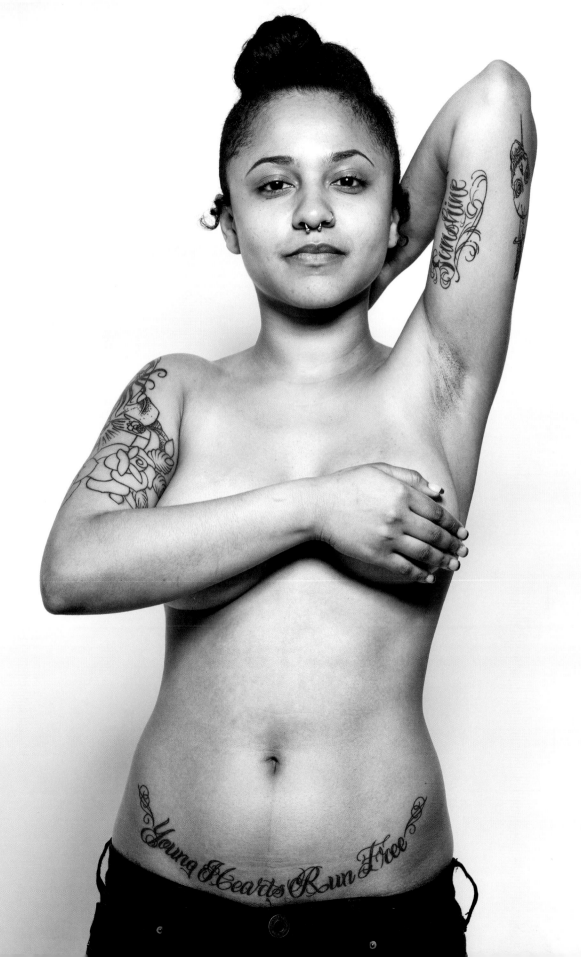

"My back piece is a reminder that everything we need is within us, it simply depends on how we look at things."

MOLLY BALLERSTEIN, 23, THEATRE ARTIST

How much have you spent on your tattoos? **Only $1,800 on my five tattoos.**

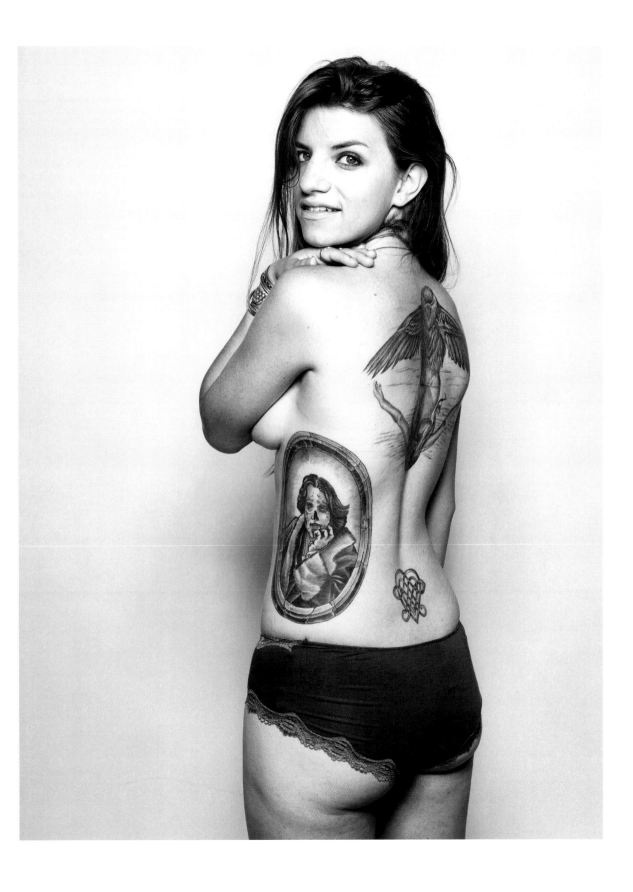

"I just started my right sleeve with an up close, portrait-style depiction of a zombie pirate. The theme of the sleeve is pirates—above water above the elbow and below water below the elbow. It reminds me of playing on my parent's porch with my brother, pretending we were on a pirate ship."

ALI HASSAN, 27, BASS PLAYER IN WILDSTREET/PRODUCER/ENGINEER

How much have you spent on your tattoos? **Thankfully I worked at a [tattoo] shop with friends, so a number of them were free. I'd say I've spent just over $2,000.**

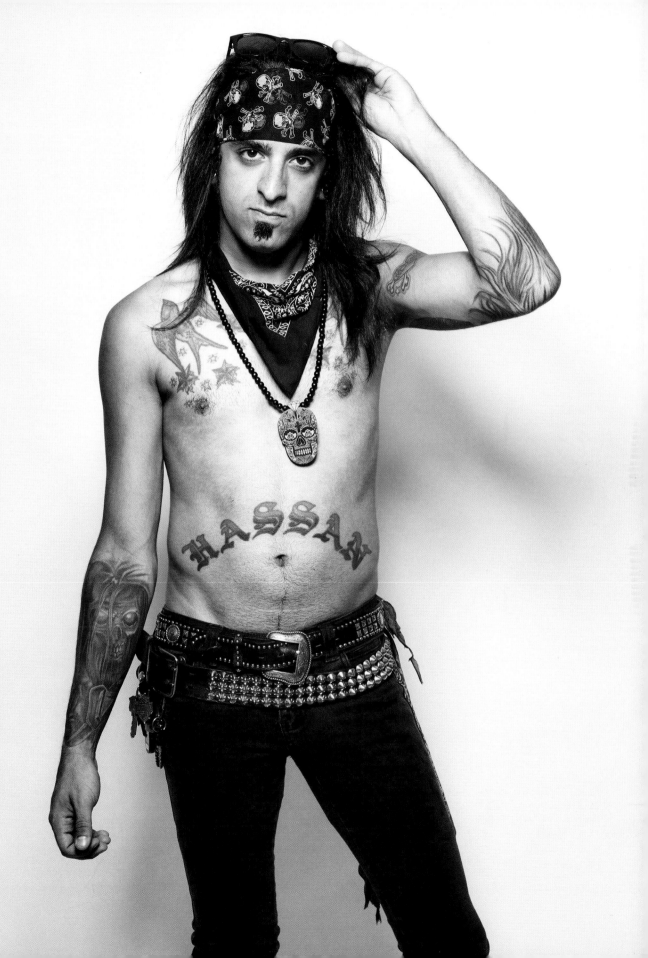

LU BAEZ, 26, MUSICIAN/HAIRSTYLIST

How much have you spent on your tattoos? **I have no idea.**

What inspired them? **The sleeve on my left arm is a tribute to the Mexican art calendars that hung in my Tia's (aunt's) kitchen during my childhood, but with a dark twist.**

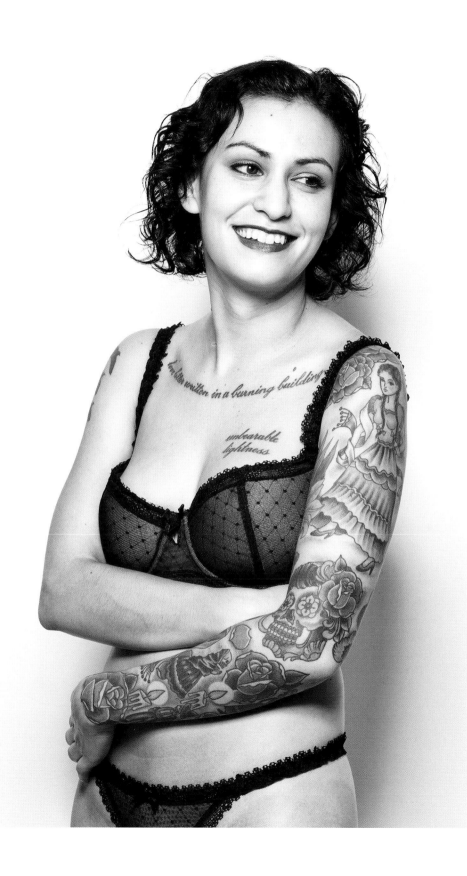

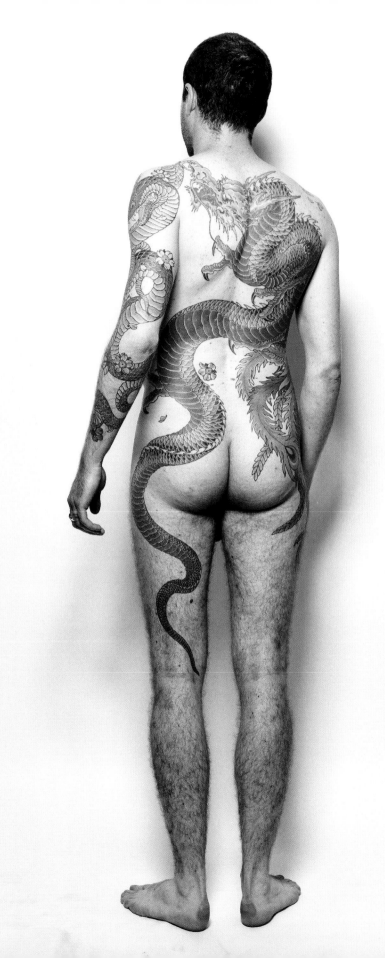

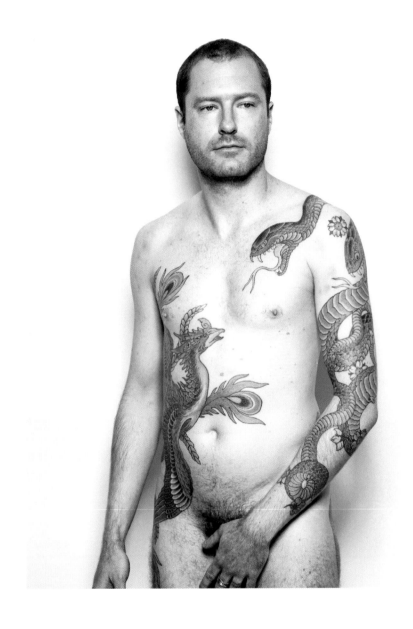

DAVID HINES, 33, FINANCE/ART

How much have you spent on your tattoos? **No comment.**

What about time? **About one hundred hours, over two years,
every two weeks with some breaks between sections.**

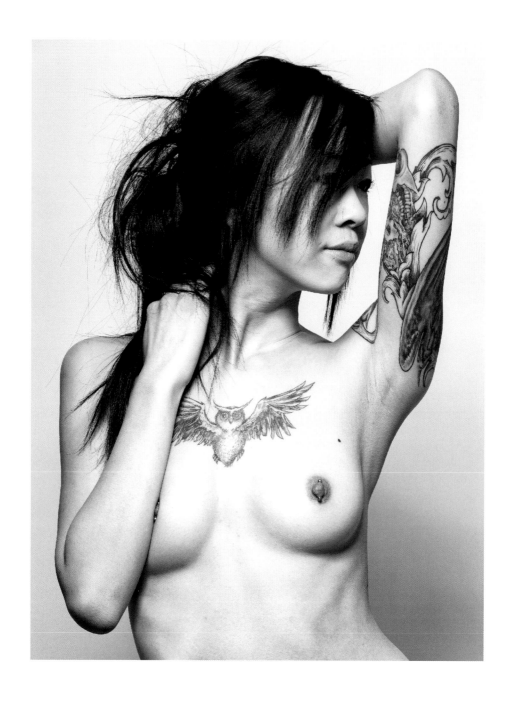

JESSICA HWANG, 21, JUNIOR BROKER, MODEL, ASPIRING ARTIST

How much have you spent on your tattoos? **Around $3,000.**

What attracted you about tattoos? **Tattoos are about the experience as well as the end result. I love the process of doing research to find images I love, and putting things together with someone who creates a work of art on my body.**

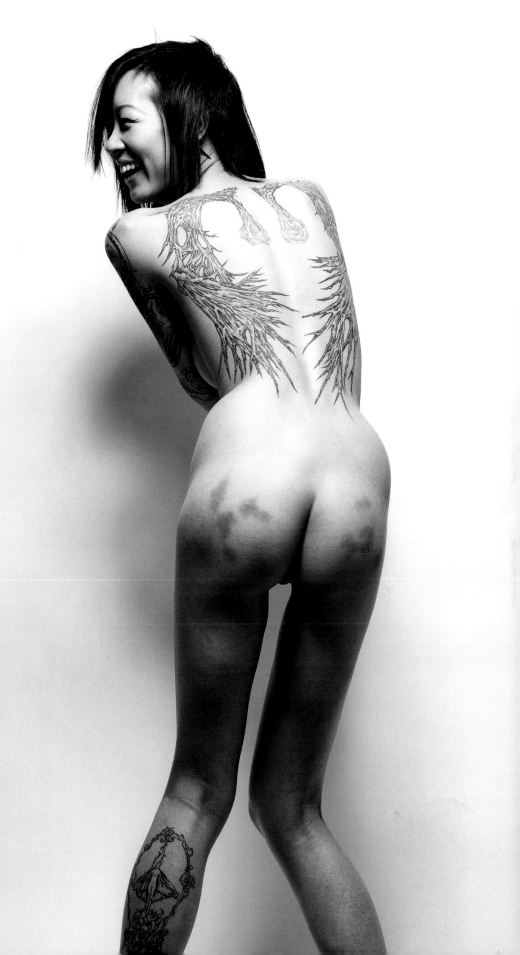

"I wish people would ask me why my tattoos are nicer than theirs."

JAMIE RYSCIK, 36, TATTOO ARTIST

How much have you spent on your tattoos? **Too much.**

First tattoo? **A tribal on my ankle. I did it myself and I chose it because I didn't know any better.**

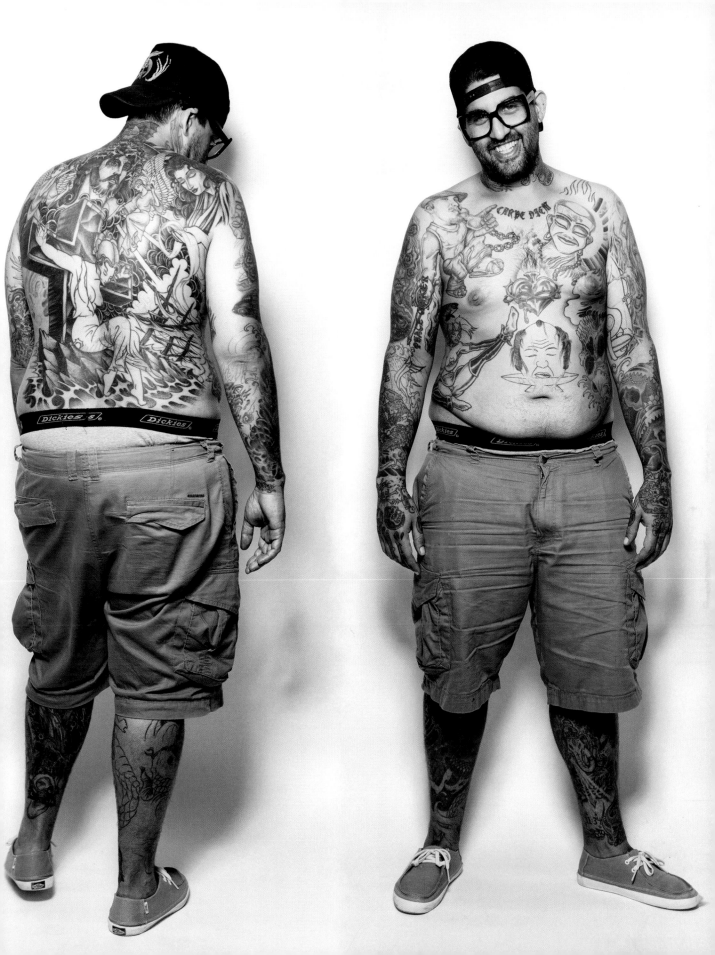

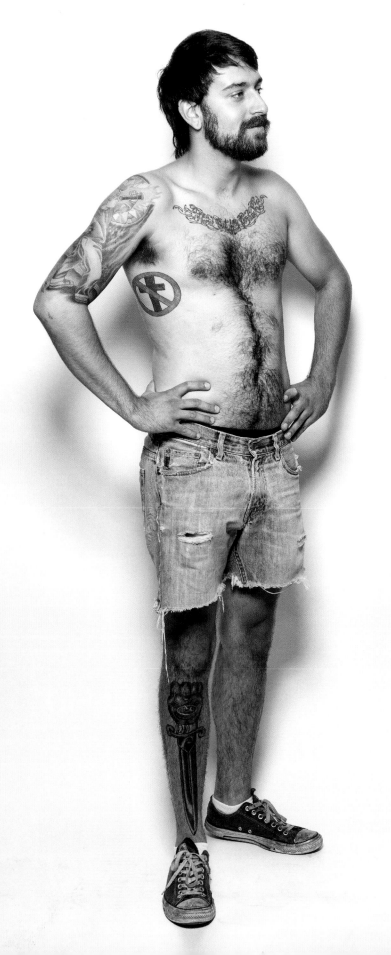

GREG BAKER, 24, BEER SALESMAN

How much have you spent on your tattoos? **Approx $2,000.**

Last tattoo? **Some color on my arm. It reminds me that I'll always be a child in some ways.**

"When I work with a tattoo artist,
I pick a concept and we jump right in,
finding a composition first
and worrying about the details later."

JOSH ROVNER, 22, COURIER

How much have you spent on your tattoos? **Hard to say. When friends tattoo you, just tip generously.**

Which tattoo took the longest to complete? **Dave Wallin, owner of 8 of Swords**
free handed the group of Peregrine falcons on my left arm for a full day.
They compliment the elephants he freehanded on my left leg a few years ago.

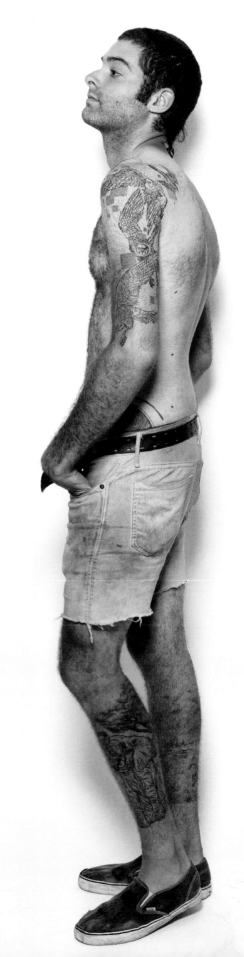

"The script on my chest is for my best friends and family and the people who helped me through tough times."

JAMES GALLAGHER, 25, NYU GRAD STUDENT

How much have you spent on your tattoos? **Too much. I'd say around $2,000 so far and it's only going up.**

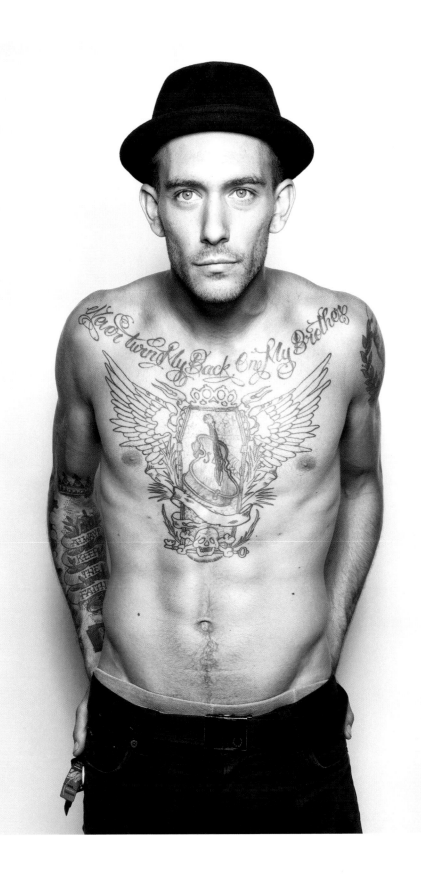

"It's always fun to show off the artwork on my body. I'm like a living art gallery."

STEVE QUESTED, 26, GRAPHIC DESIGNER

How much have you spent on your tattoos? **Over $1,500.**

Most recent ink? **The geometric flower on my kneecap was done by Mina Aoki of Daredevil Tattoo on the Lower East Side in Manhattan. She's only been tattooing for about a year, so I let her practice on my body.**

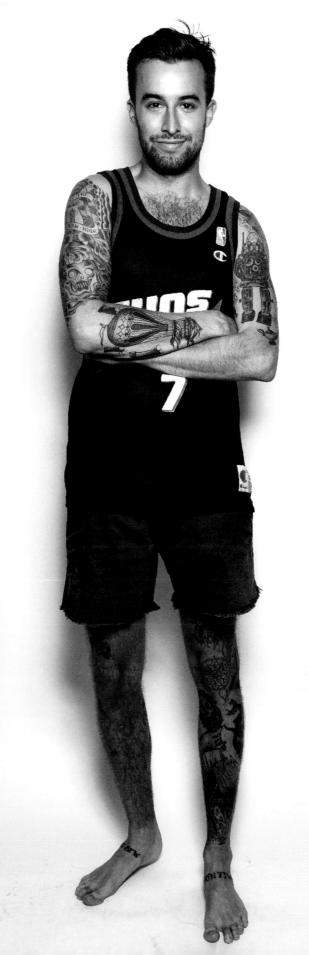

"My tattoos are kind of a way of talking about myself without speaking."

CAITLIN GRAMM, 25, SHIPPING CLERK

How much have you spent on your tattoos? **$1,000-$2,000. I started tattooing myself because I couldn't afford as many as I wanted.**

How did you do your first self-done tattoo? **I did it before I really understood how stick and poke worked. I used a box cutter to scratch the outline of a carton of French fries into my leg and pressed India ink into the wound. Unsurprisingly it was pretty painful and scarred more than healed.**

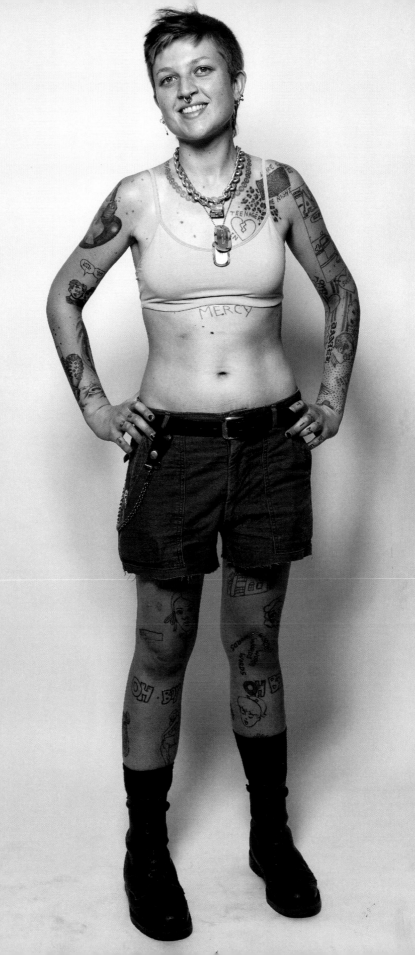

"*The first book I ever took out of the library was a photo book on tattoos by an artist called Spider Webb. I started tattooing out of my home in New Orleans at age eighteen. I picked it up again five years ago in Brooklyn.*"

ADAM KOROTHY, 38, TATTOO ARTIST

What is the most time you've spent on a tattoo in one sitting?
Six hours. Of course I have also done large tattoos that take several sittings.

What is your relationship like with a person once their tattoo is complete?
It depends on the client. Some of my very good friends have started as clients.

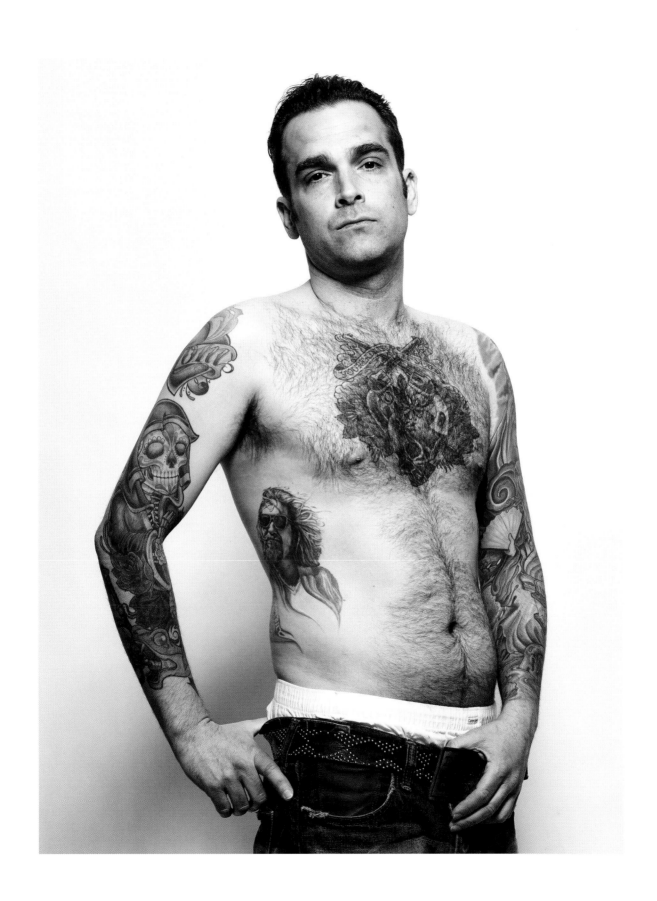

"My first tattoo is actually the least attractive, but I'll always love it because it represents who I was at that point in my life. I was eighteen and trying to define myself so I got the word for artist in Gaelic on my forearm."

RYAN MALARKEY, 23, DESIGNER

How much have you spent on your tattoos? **Probably close to $10,000.**

What was your last tattoo? **My tattoos are mostly works in progress. I'm trying to sample works from many artists that I appreciate, so there really is no 'latest' or no 'end' when it's a lifelong process.**

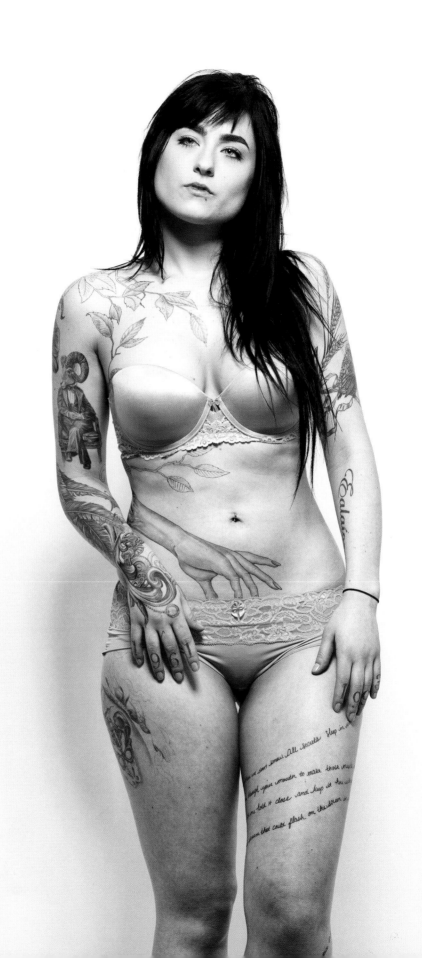

"My chest piece is after the Johnny Cash song 'Sunday Morning Coming Down'– most badass man on the planet."

LIZA SOKOL, 19, STUDENT/WRITER

How much have you spent on your tattoos? **About $900-$1,000.**

What about your chest piece? **That was a gift from my dad. He's got full sleeves. He's the second most badass man on the planet after Johnny Cash.**

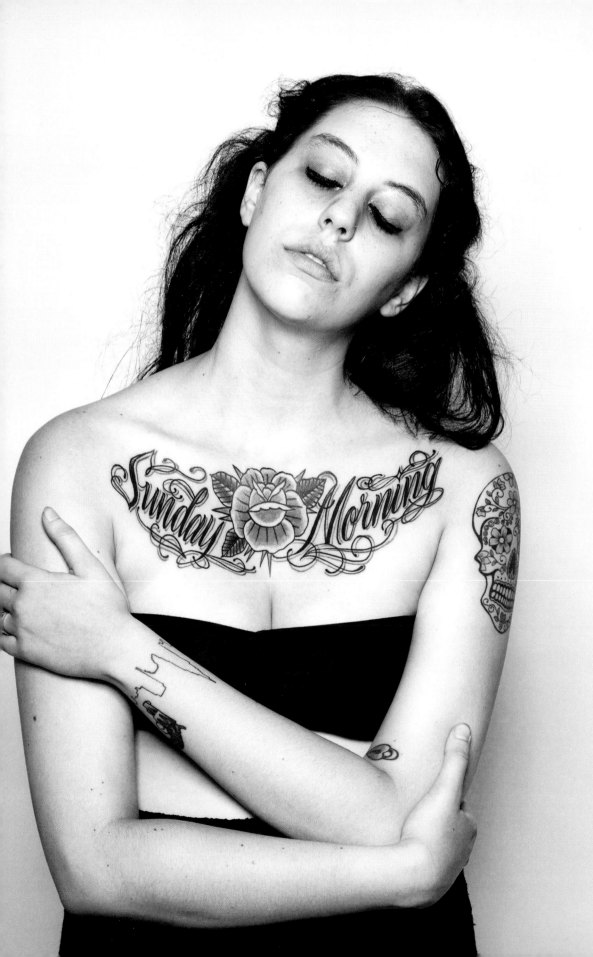

For Alexa

Acknowledgments

The publishers are grateful to everyone who gave up their time to pose for a portrait for this book whether they appear on these pages or not.

Paul Nathan was born in Auckland, New Zealand. He has a degree in Art History and Art Theory from the University of Canterbury and has studied the fulltime programs at Sotheby's in London and the International Center for Photography (ICP) in New York. His editorial work has been published in books, magazines, and newspapers.

Nadine Rubin Nathan began her career as editor-in-chief of *Elle* South Africa. After relocating to New York in 2004, she contributed to *Harper's Bazaar* and was senior editor at Assouline Publishing. Her writing has also been published in the *New York Times*. She has an MA in arts and culture journalism from Columbia University. Paul and Nadine currently live in Williamsburg, Brooklyn with their daughter Alexa Phoebe Nathan.

© 2012 Pelluceo
www.pelluceo.com

Cover image: Paul Nathan
Designed by: James Gamboa and Gabriela Bornstein

Printed in China

ISBN: 978-0-9851368-0-2
10 9 8 7 6 5 4 3 2